Here Comes Everybody

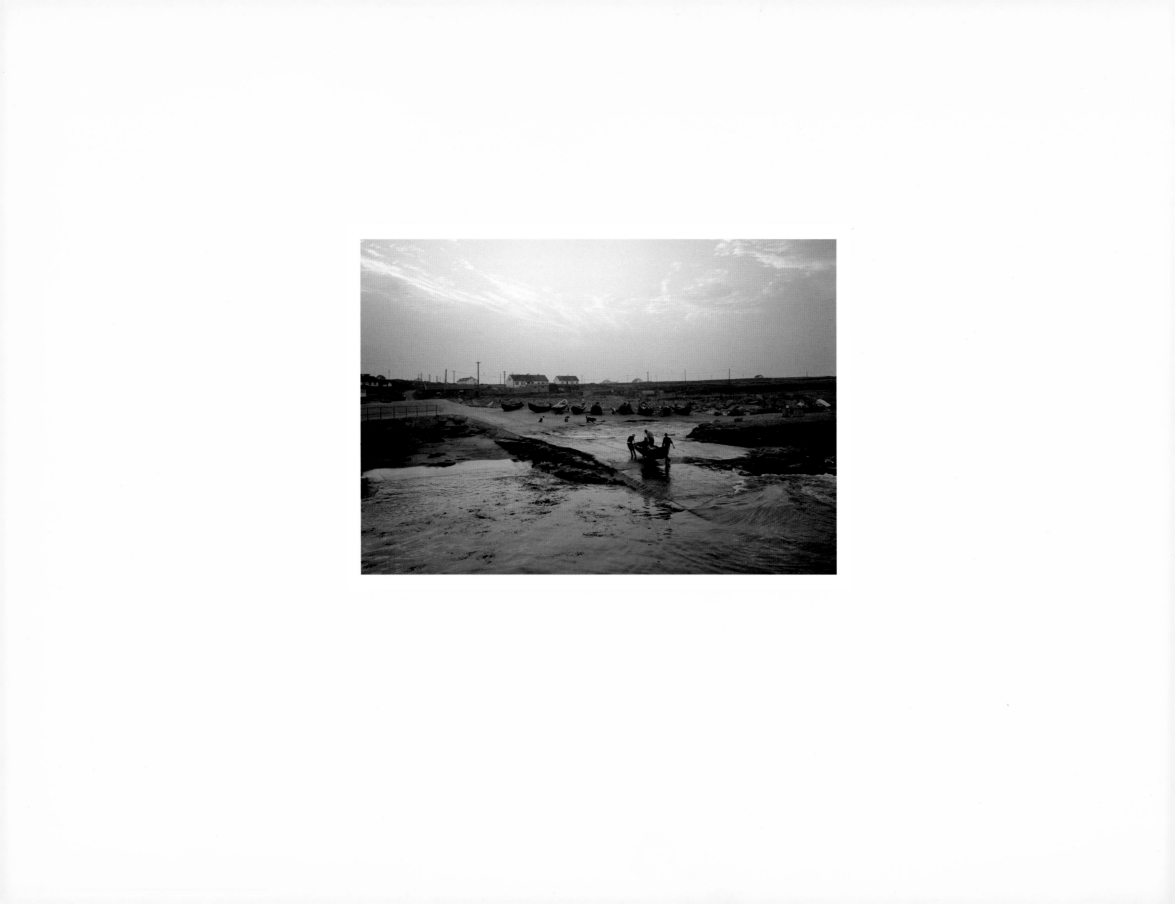

Here Comes Everybody

CHRIS KILLIP'S
IRISH PHOTOGRAPHS

Thames & Hudson

This book is a facsimile of an album that I had made of my Irish photographs and is
dedicated to the memory of my mother, 'Molly' Killip, who died in 2008 at the age of 96.

CONTENTS

In the spring of 1991 Christine Redmond, director of the Gallery of Photography in Dublin, invited me to teach a summer workshop on the Aran Islands. I had no teaching experience, but earlier that year had accepted an invitation to teach in the United States, and I thought that this workshop might be a good place to learn something of the practice. I had previously resisted going to Ireland since Markéta Luskačová, the mother of my son, and Josef Koudelka, who introduced me to her, had both photographed there, and I felt that it was not my 'territory'.

The workshop went well. I had a great time with Christine and the gang and agreed to come back another year. I also wanted to photograph in Ireland, and in 1993 planned the timing of my visit more carefully. I would teach for three days midweek in late July, allowing me to go to the annual pilgrimage at Croagh Patrick on the last Sunday of the month. Then on the first Sunday in August I would go to the pilgrimage at Máméan which the Irish photographer Tony O'Shea had told me about. O'Shea said that Máméan was small and special, very much a local event, and different, he said, from Croagh Patrick, since all the rites were sung in Irish and it was in such a beautiful place. He also cautioned me that the priest there was fierce.

On my way to Ireland again in summer 1994, I went to visit my mother in the Isle of Man. She was quite indignant about my trip and asked why I was going to Ireland yet again? Didn't I know that I was a quarter Irish? I didn't. She then went on to tell me that her mother had come from 'somewhere in the west of Ireland', and for my mother, that's all there was to say.

This much I now know. My mother's father died when she was fourteen. Her Irish mother, who raised her a Catholic in a stronghold of Primitive Methodism in the Isle of Man, died when she was twenty. My mother became a nurse so that she would have somewhere to live. The bigotry against Catholicism that she endured while growing up marked her life. Consequently, her childhood, her mother and her background were never subjects for discussion. We were also raised Catholic.

The workshops on the Aran Islands came to an end in 1995. I was then living in the United States but continued my irregular visits to Ireland, always for the same week. In the six days between the two pilgrimages I would travel and photograph, mainly in the Irish-speaking areas of the west. In May 2000 I was married in a Catholic church in the United States. Mary, my American wife from Nebraska, is a practising Catholic of Irish descent and we honeymooned in Ireland. My tenth and last visit to photograph in Ireland was in 2005.

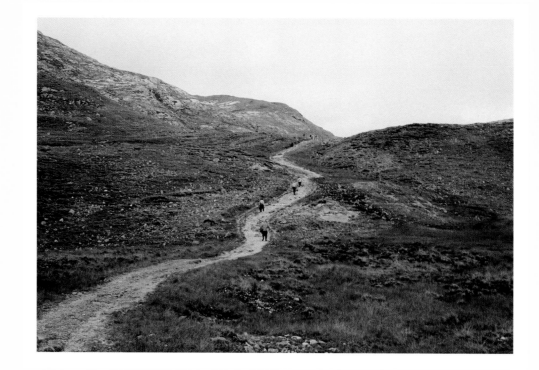

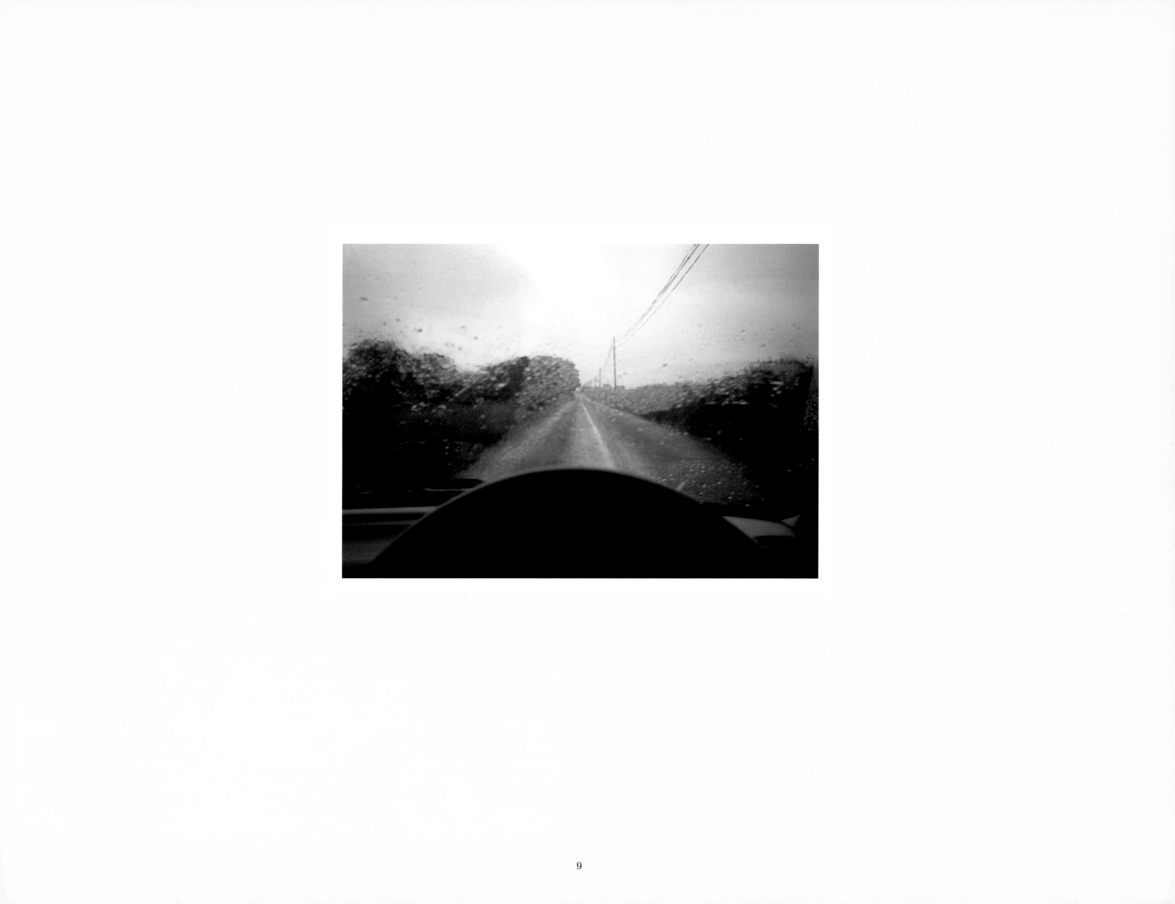

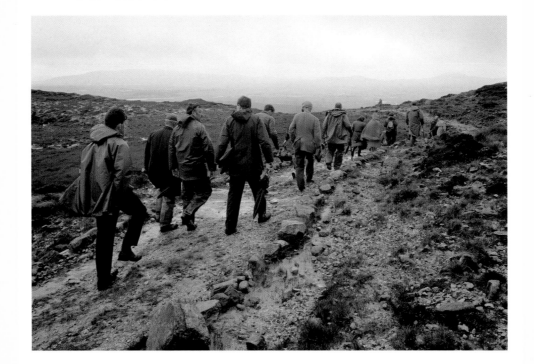

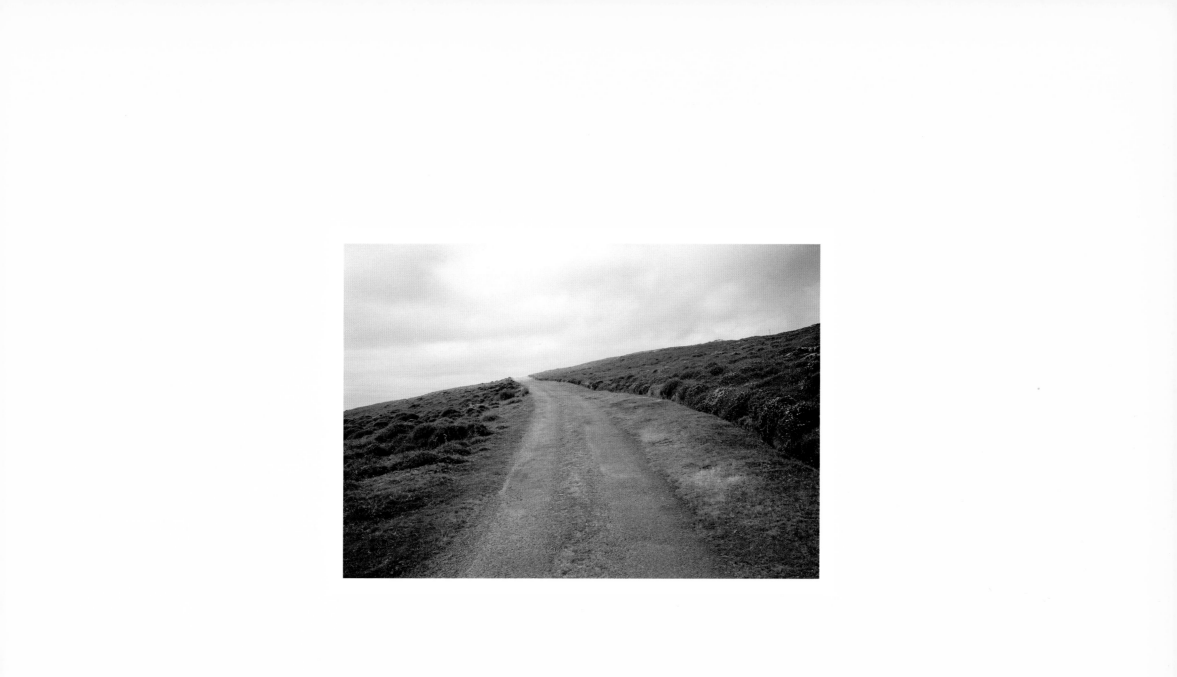

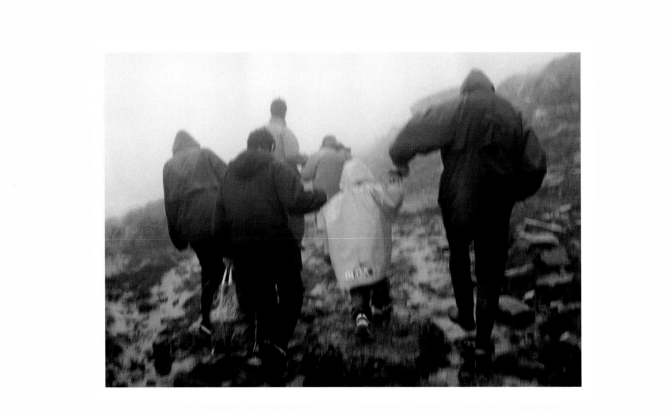

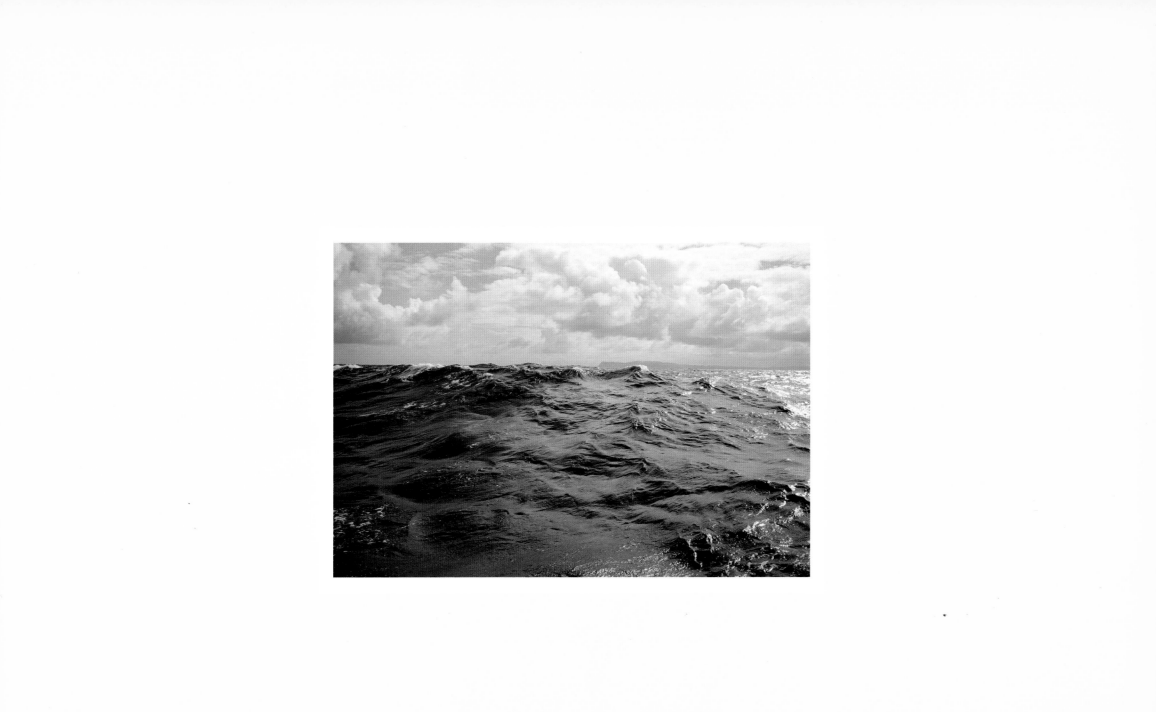

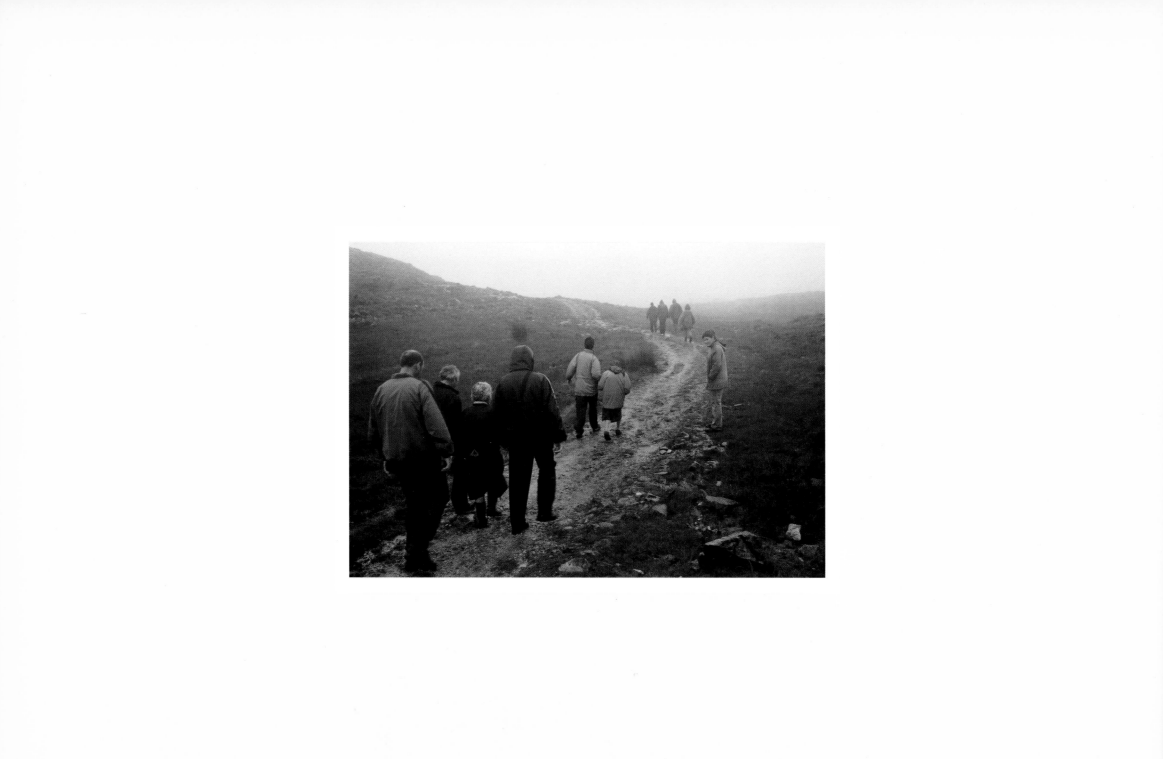

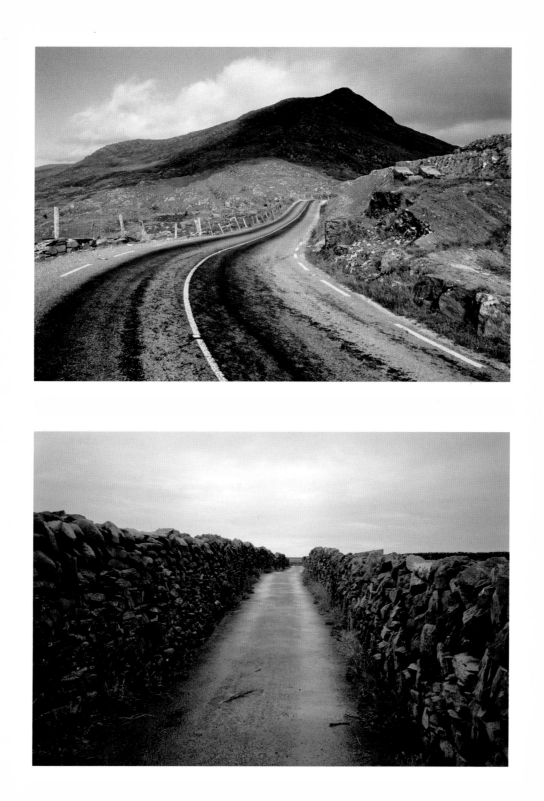

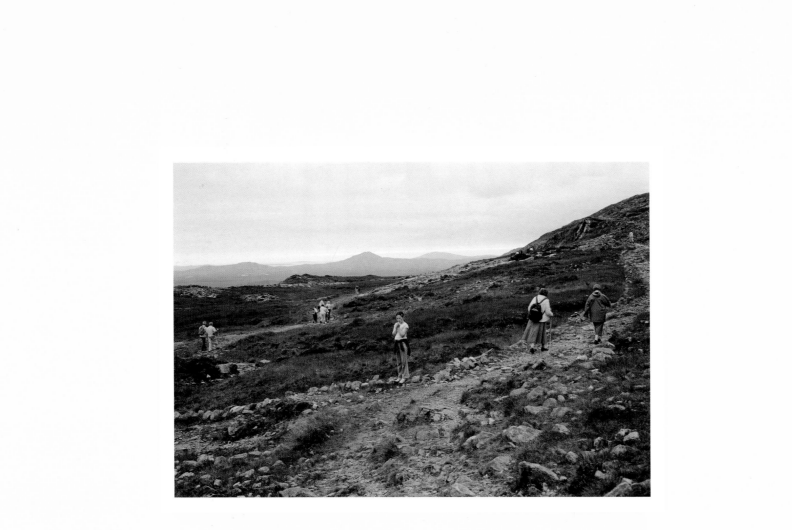

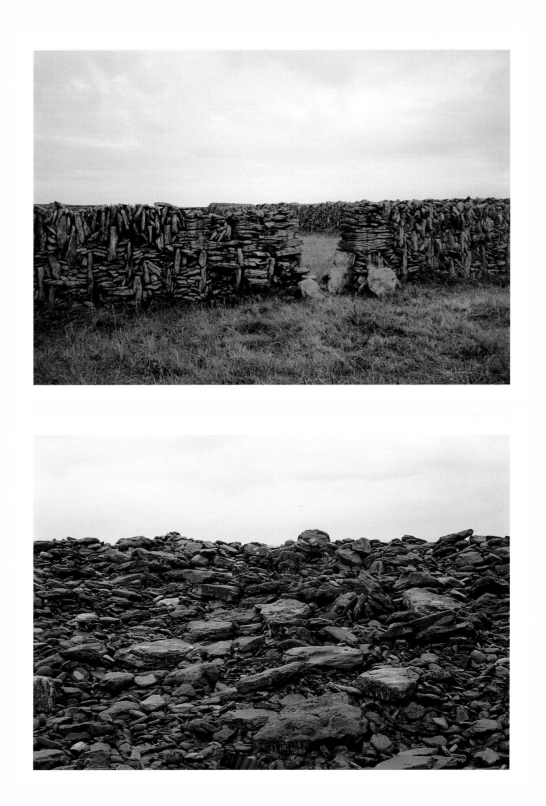

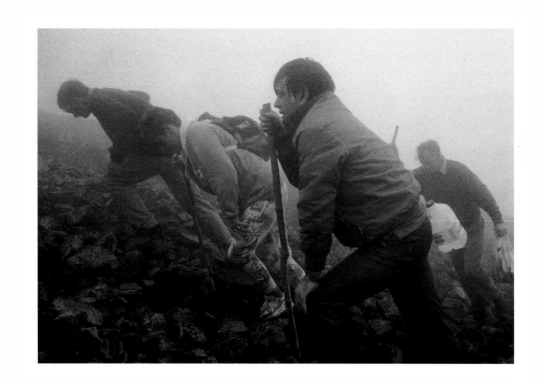

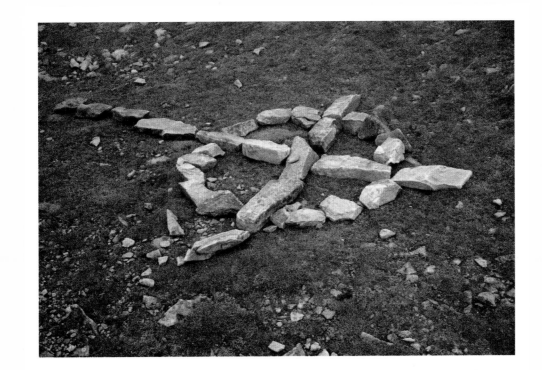

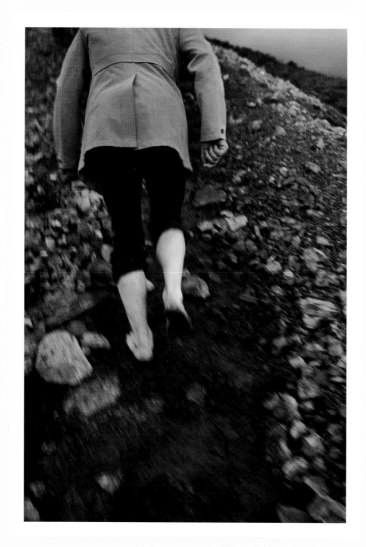

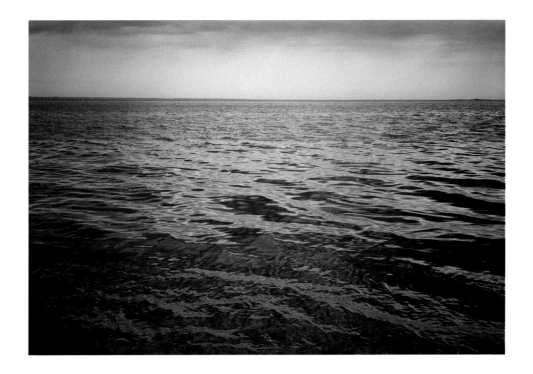

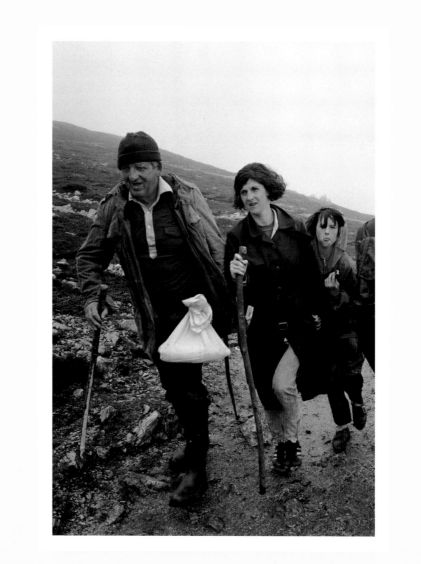

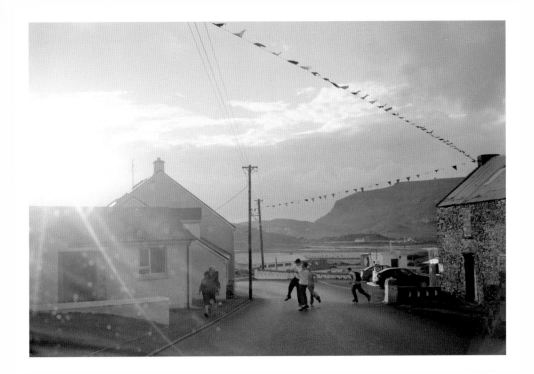

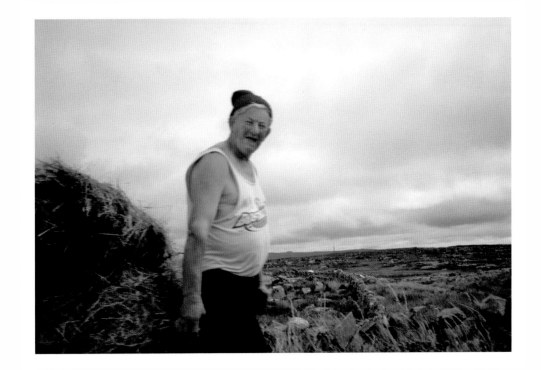

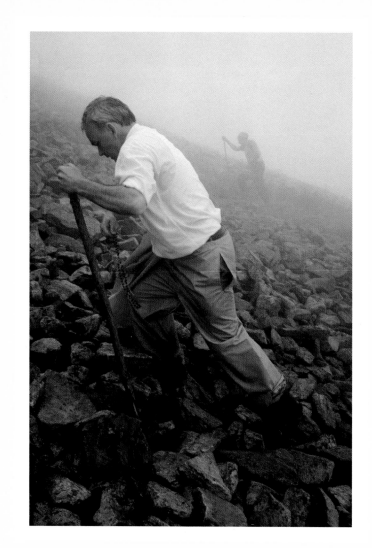

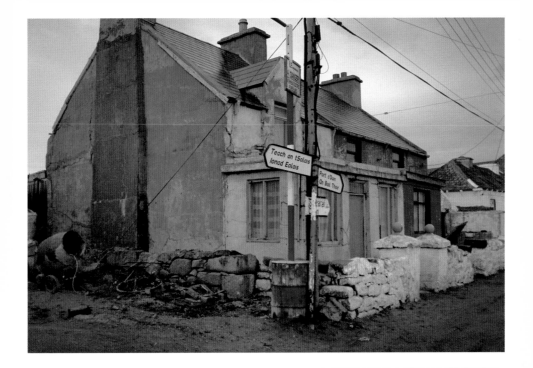

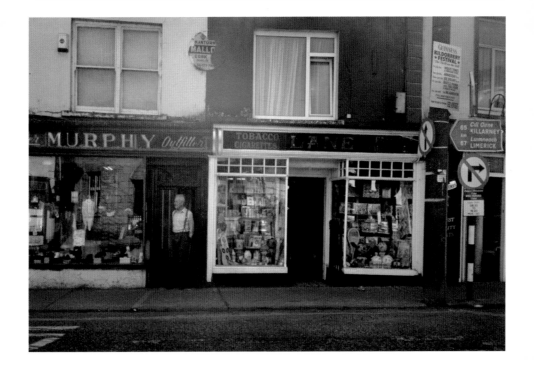

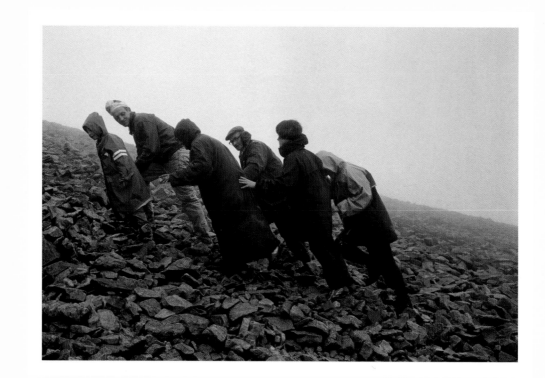

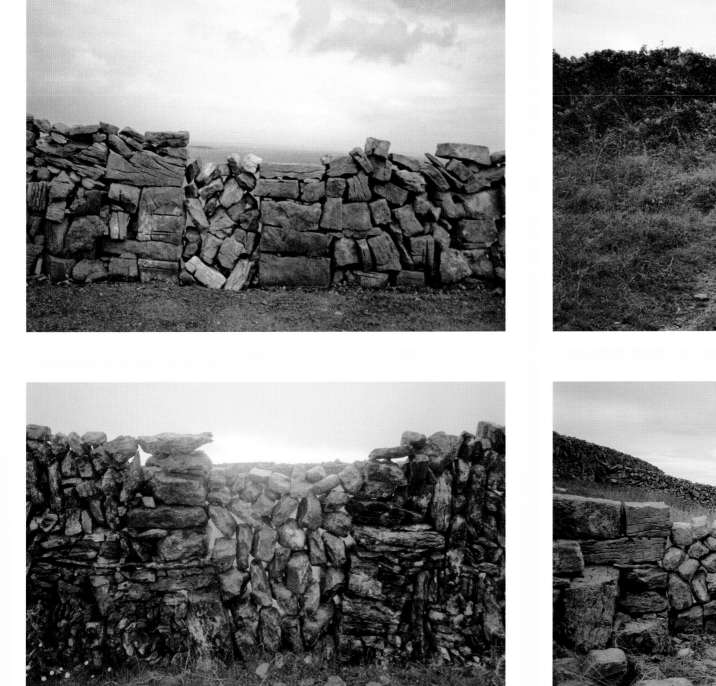
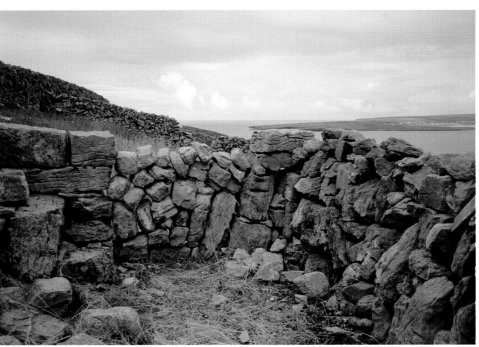

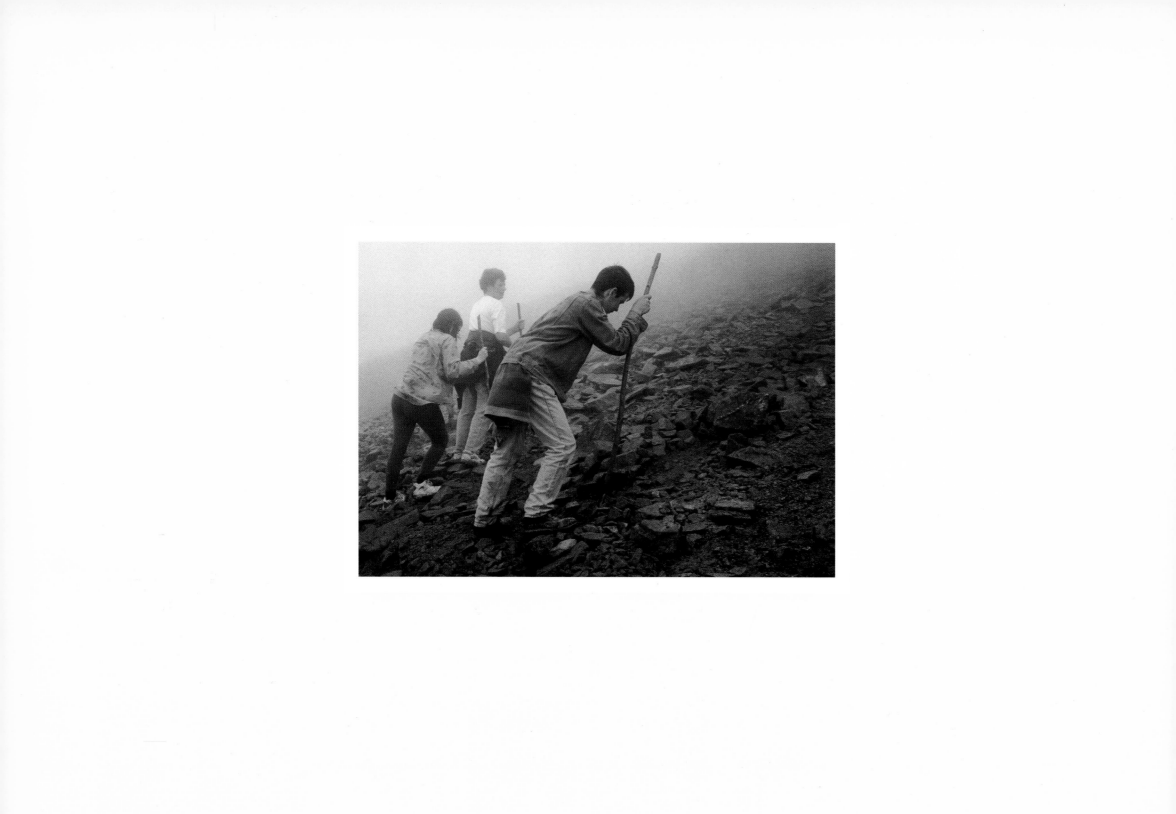

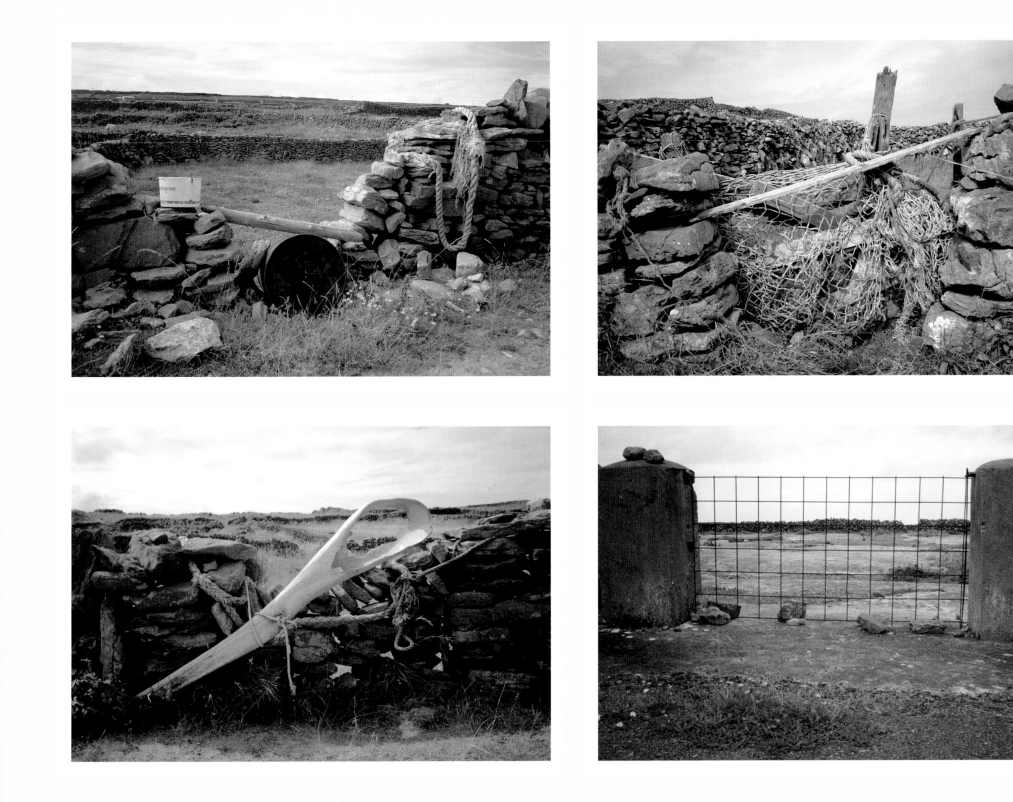

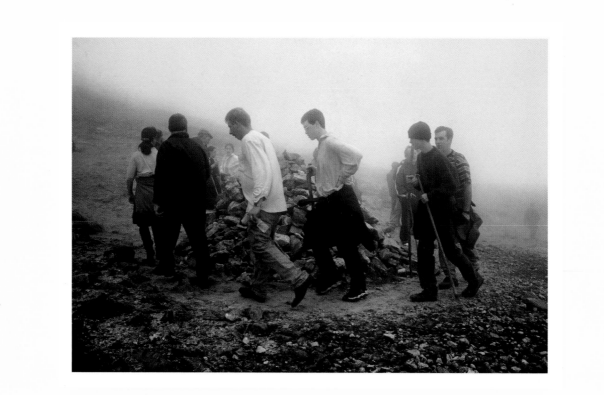

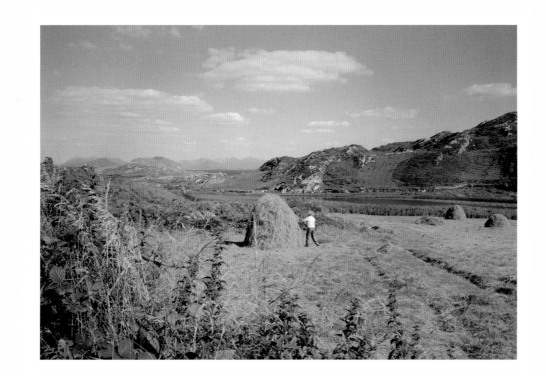

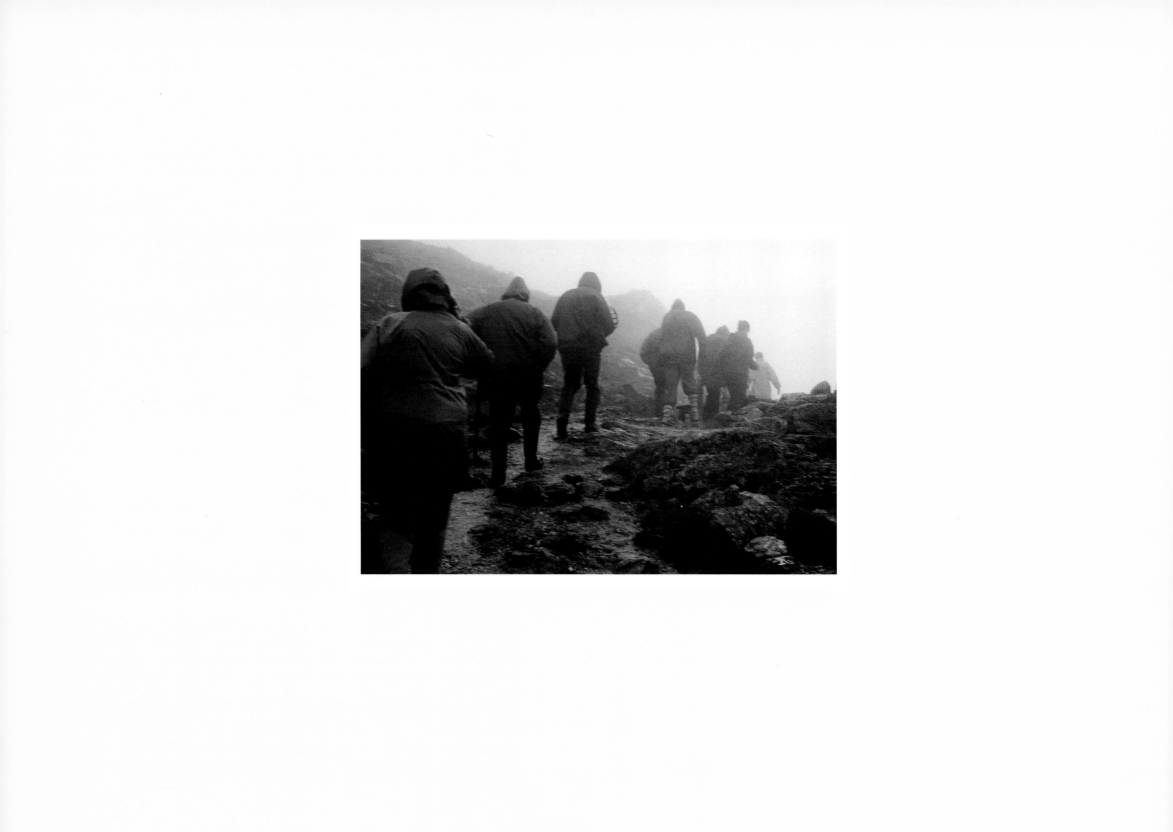

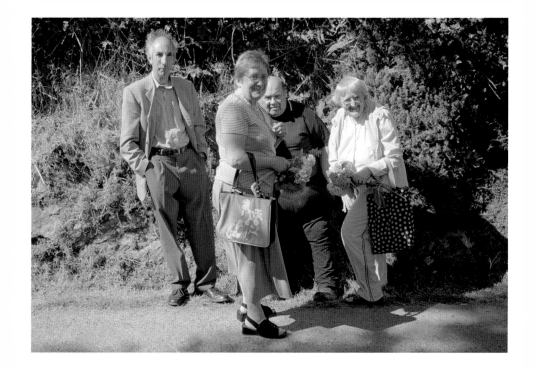

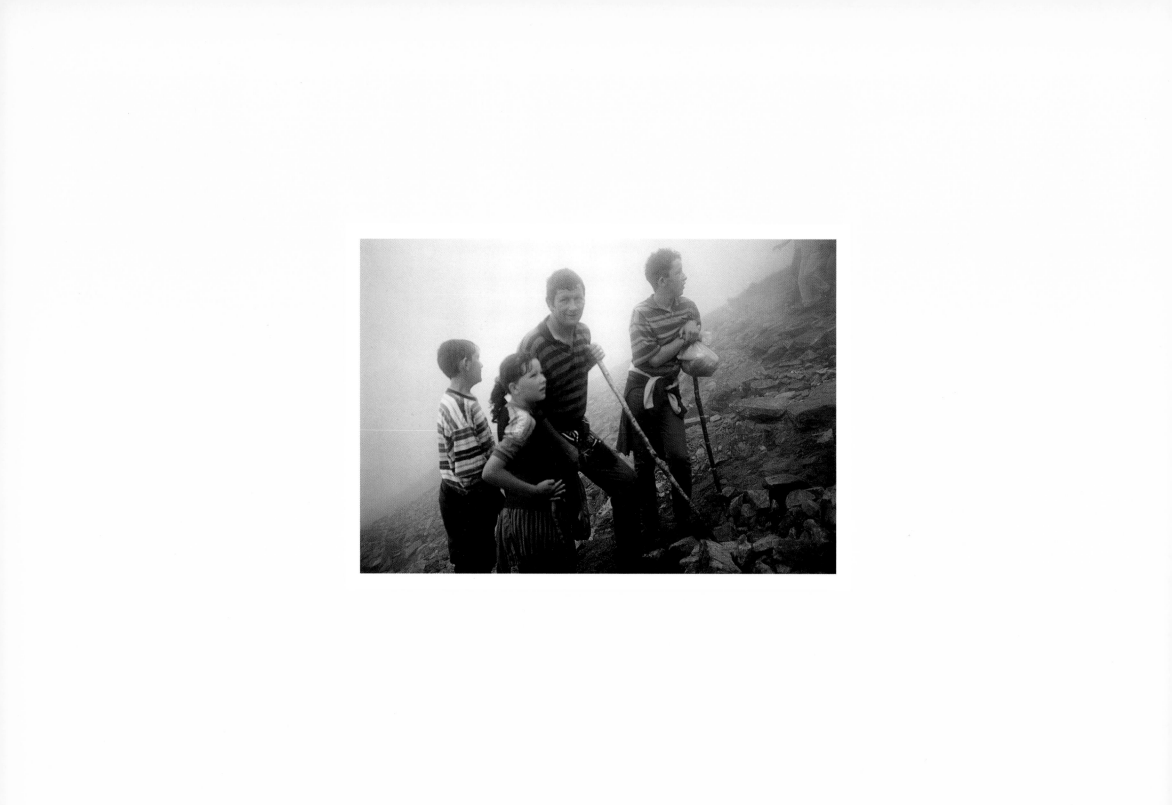

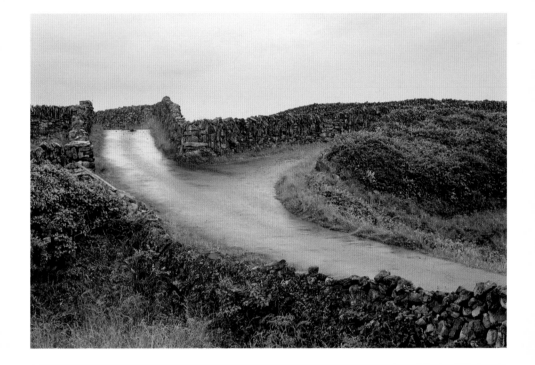

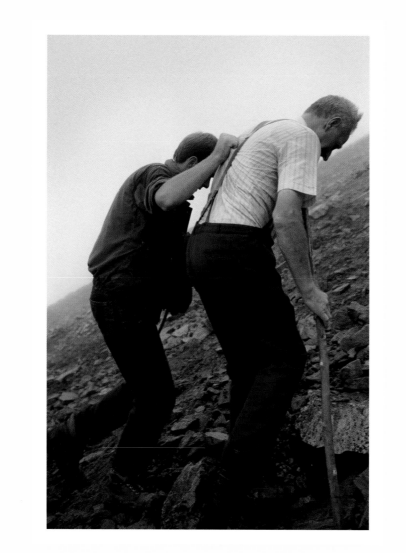

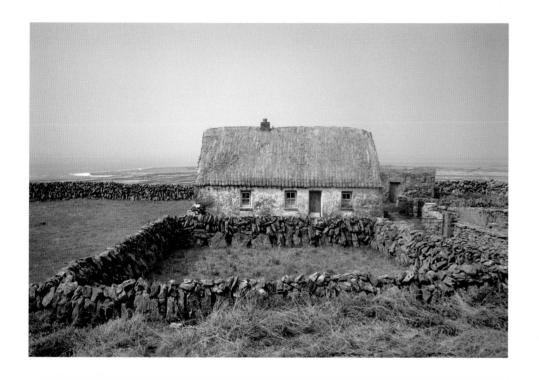

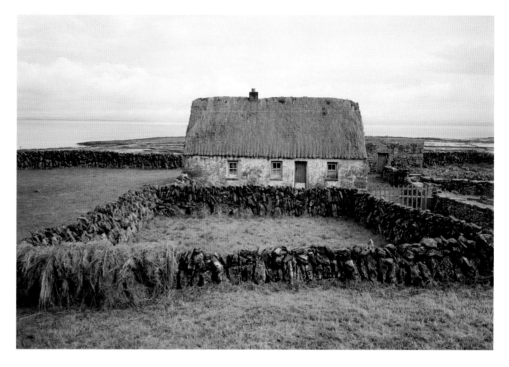

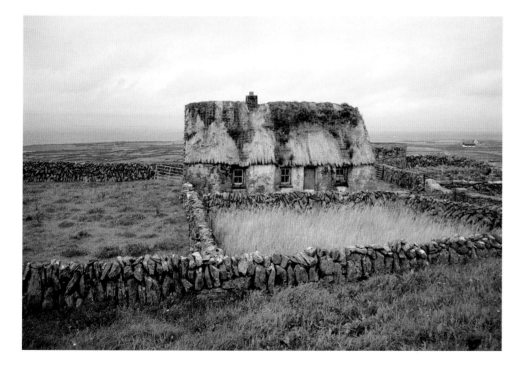

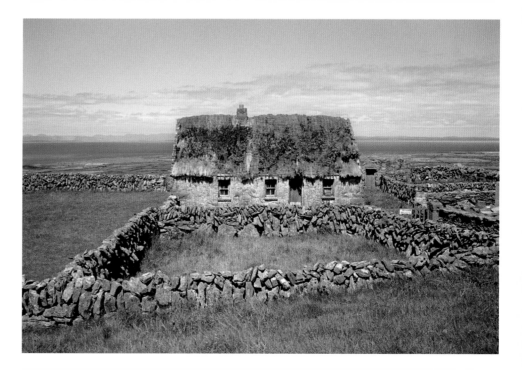

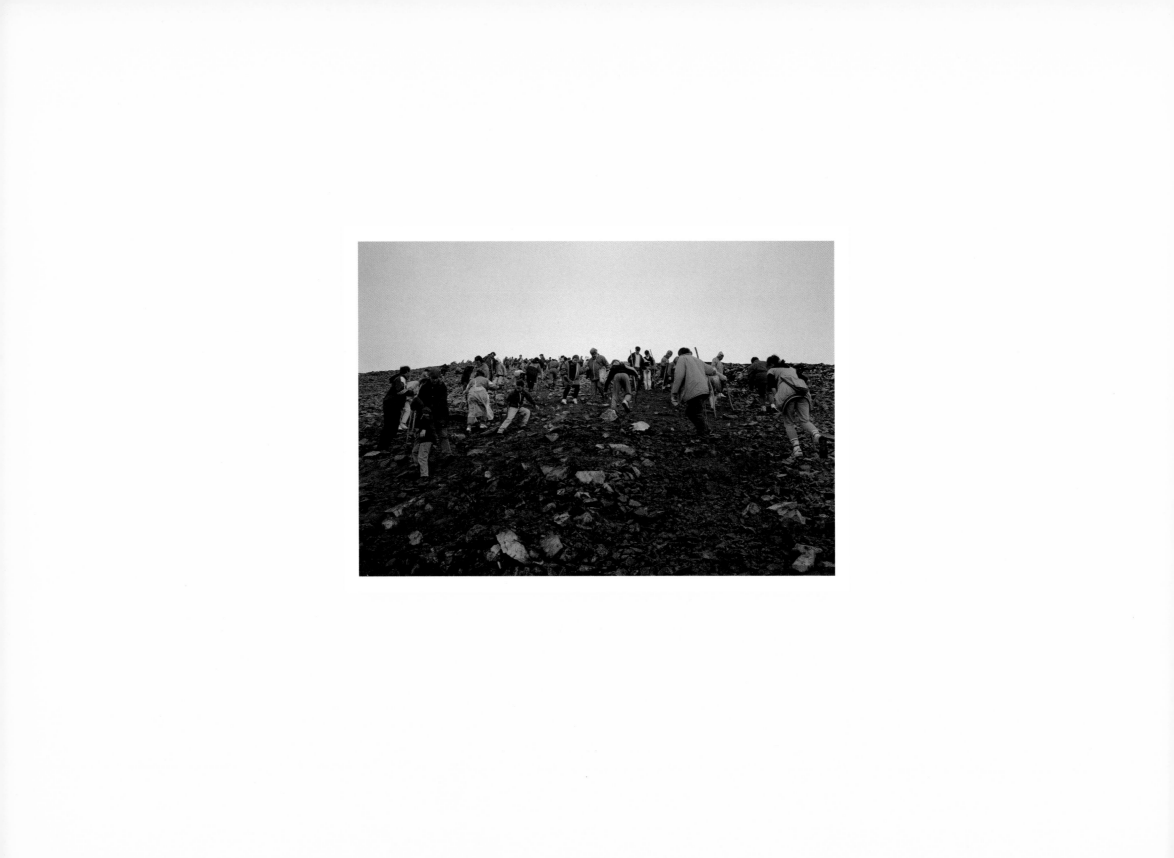

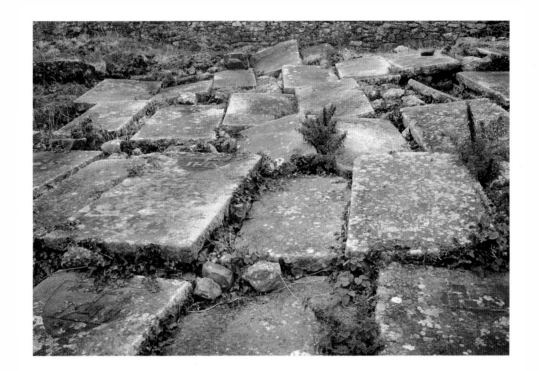

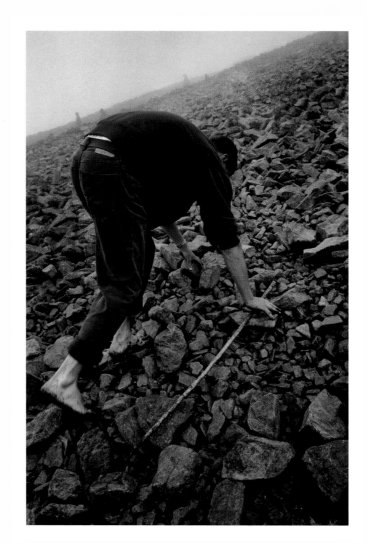

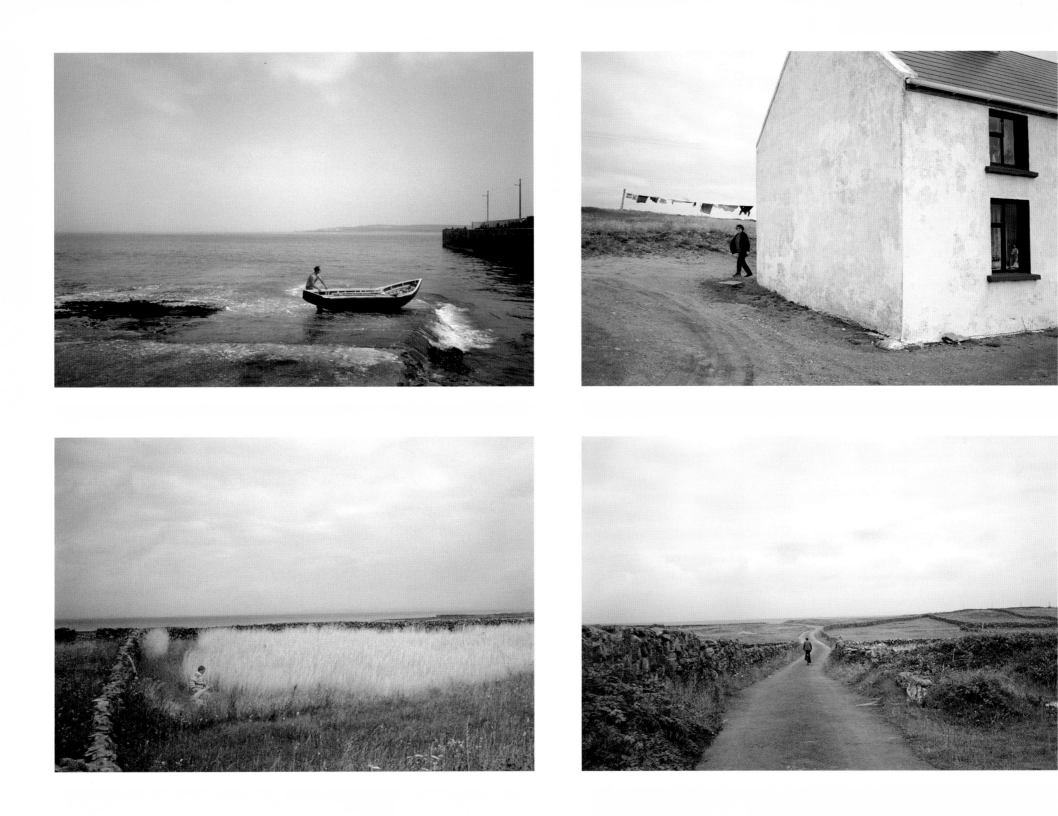

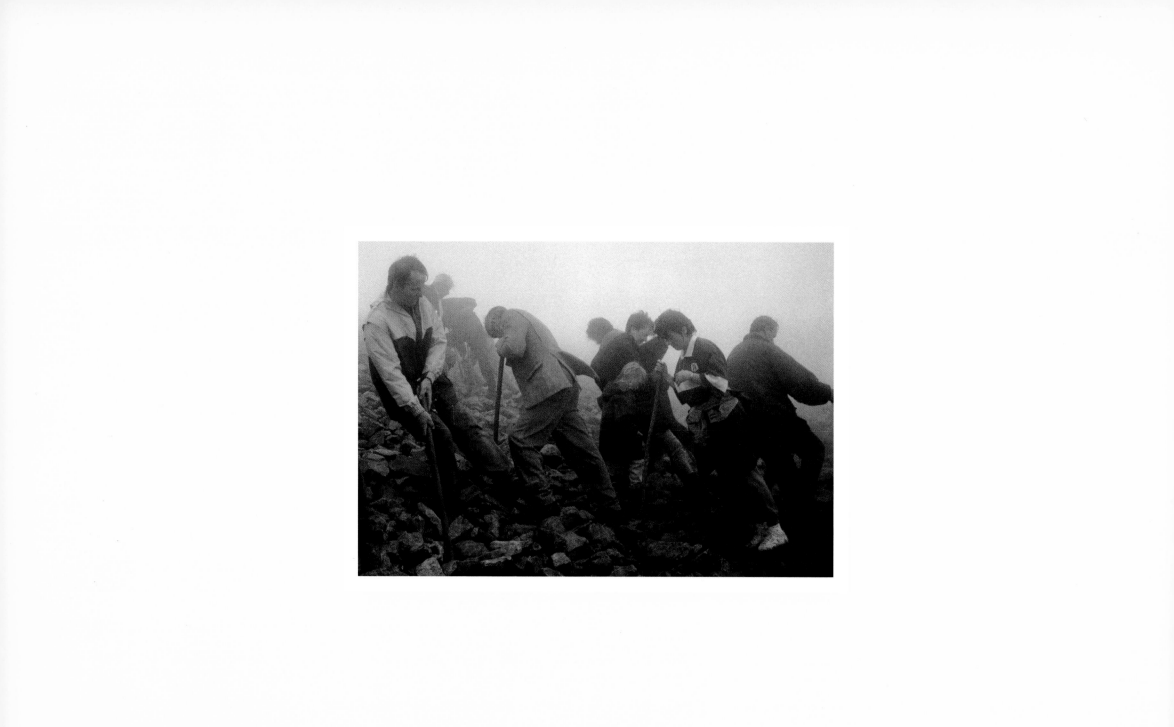

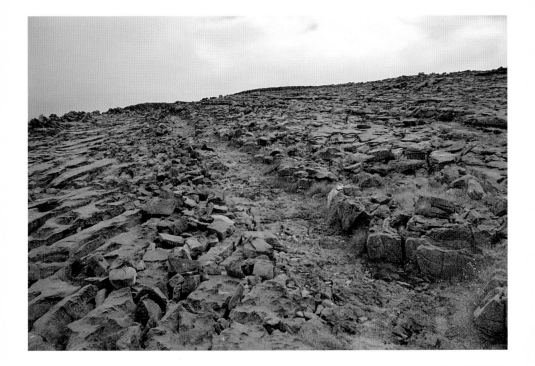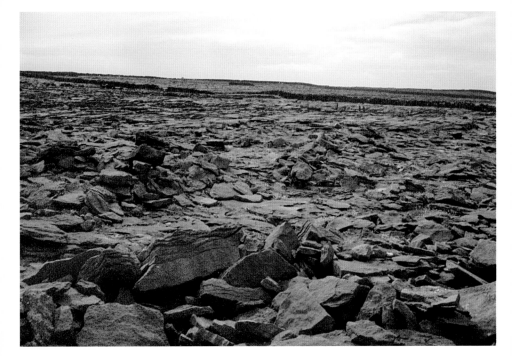

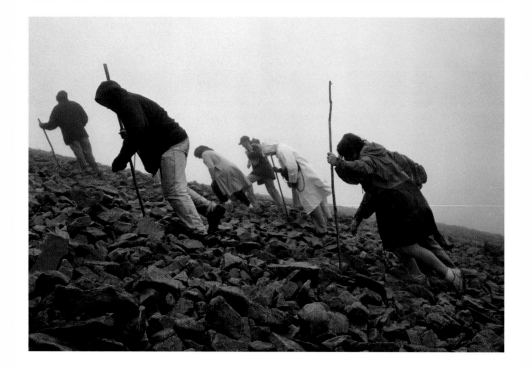

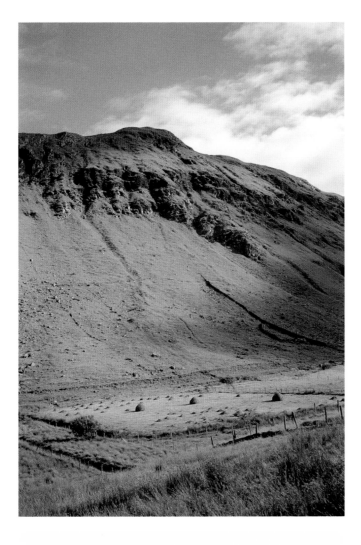

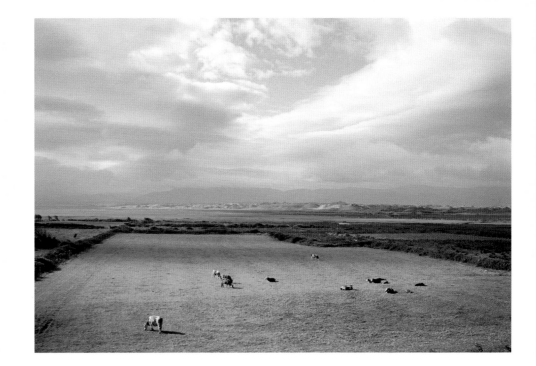

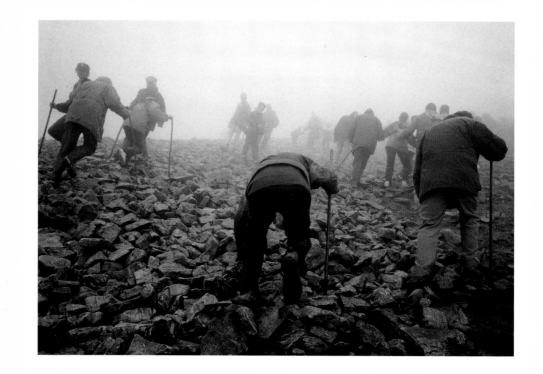

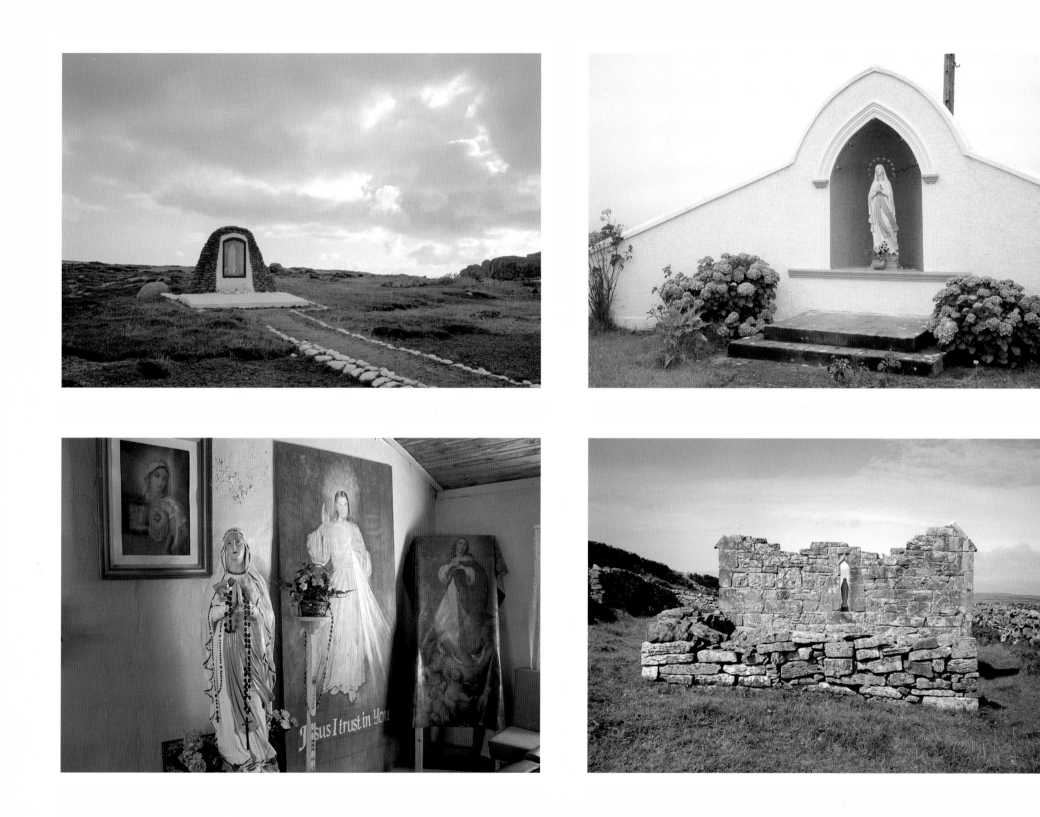

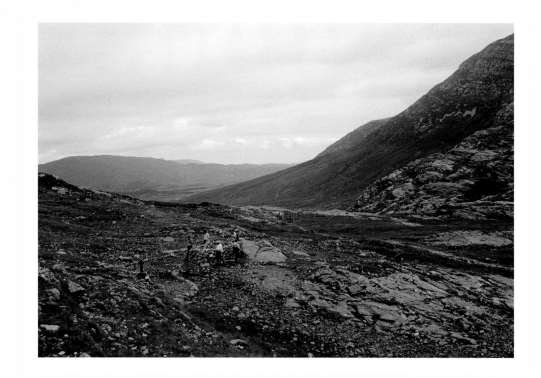

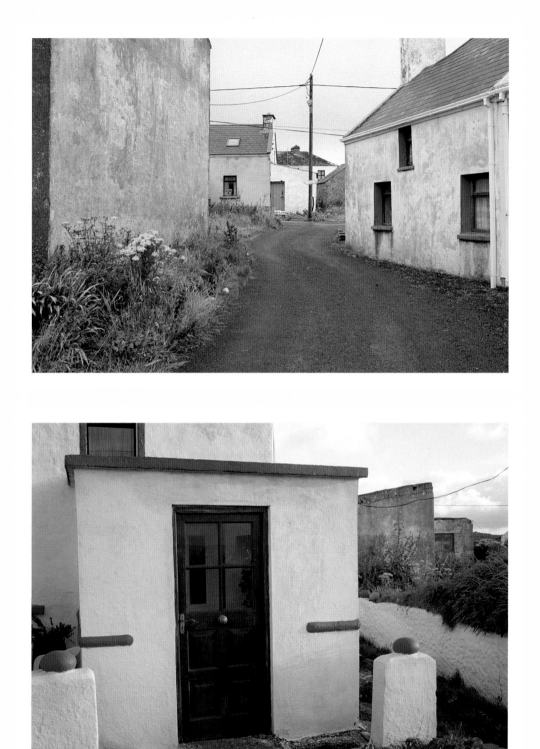

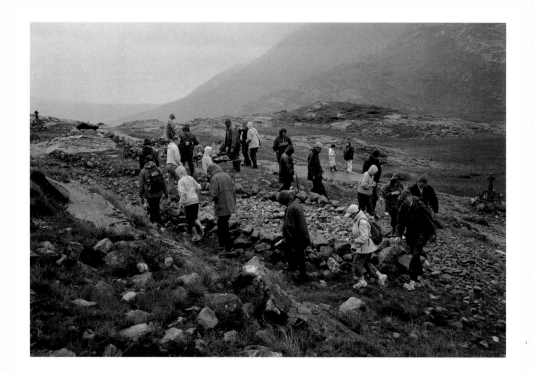

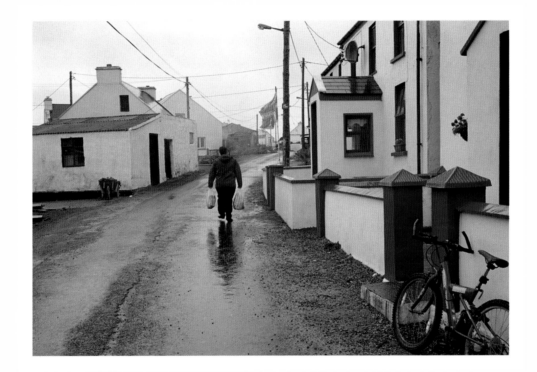

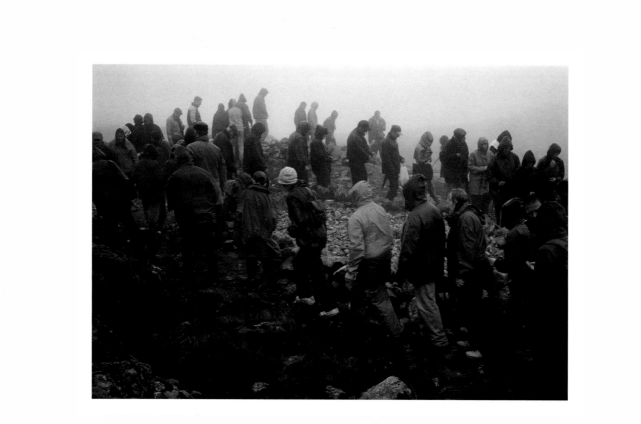

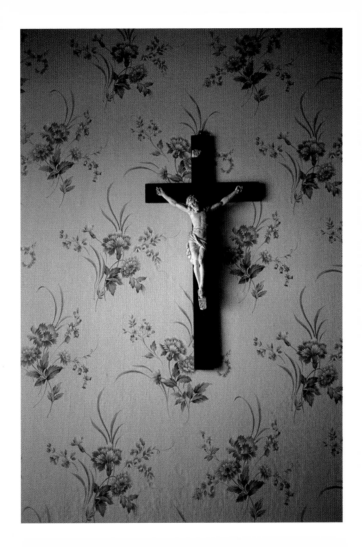

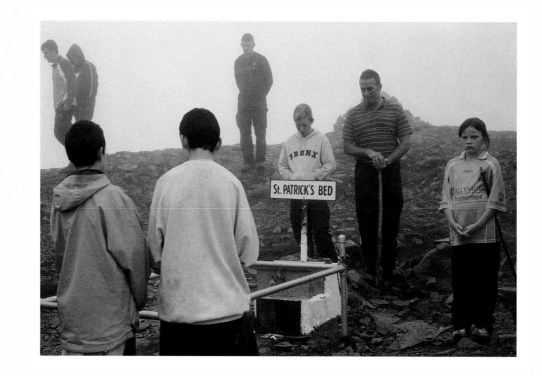

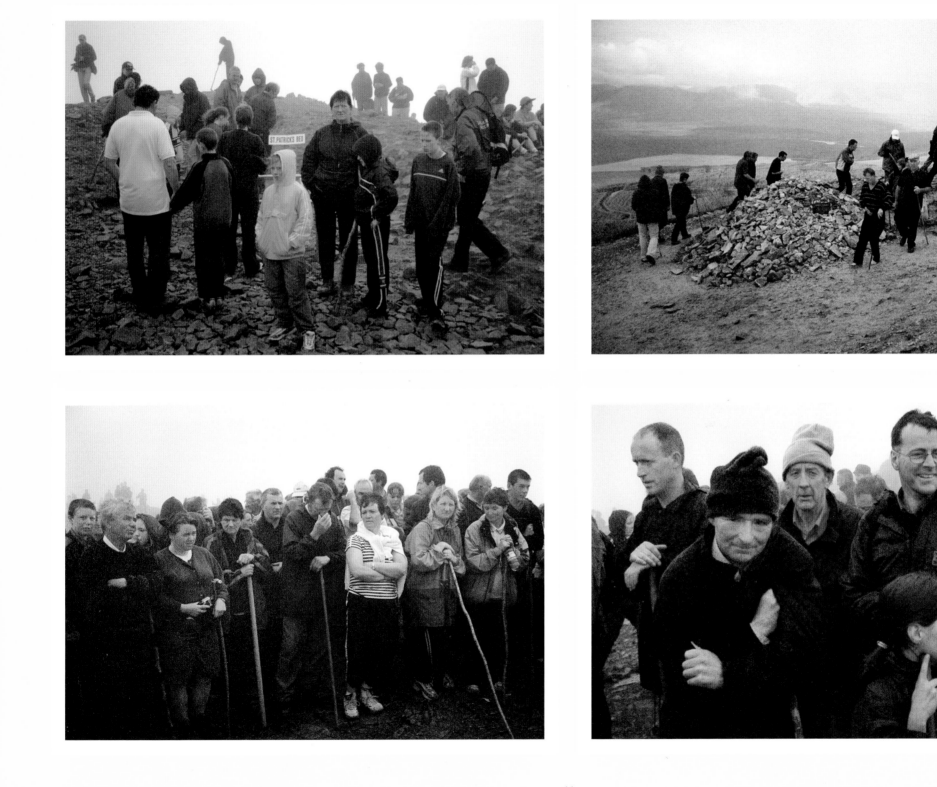

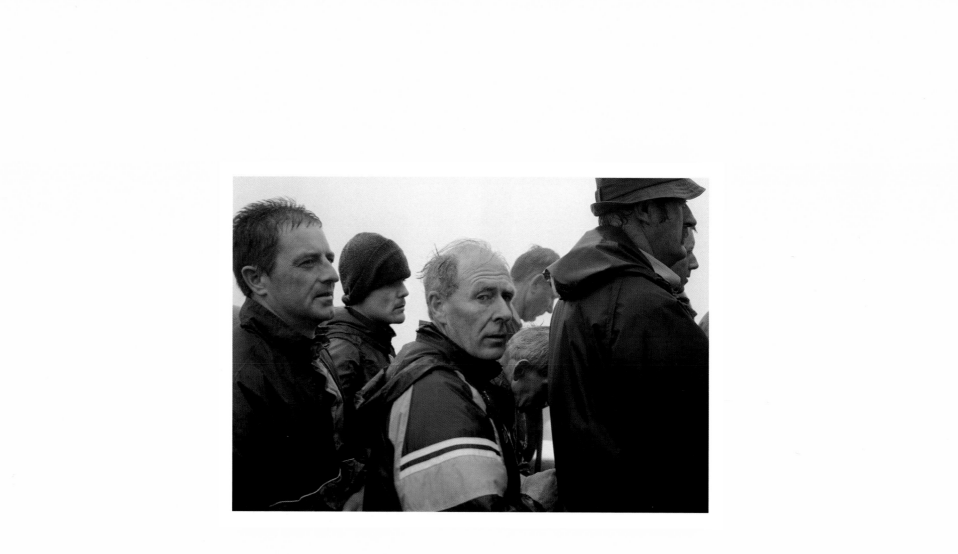

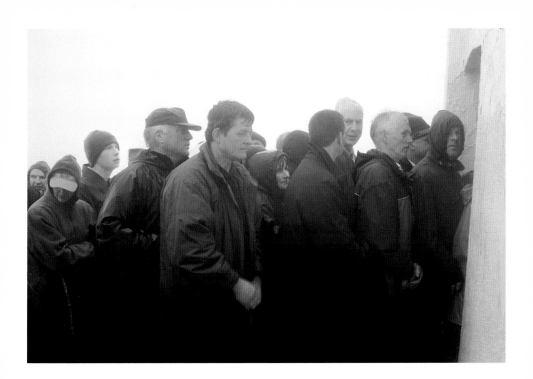

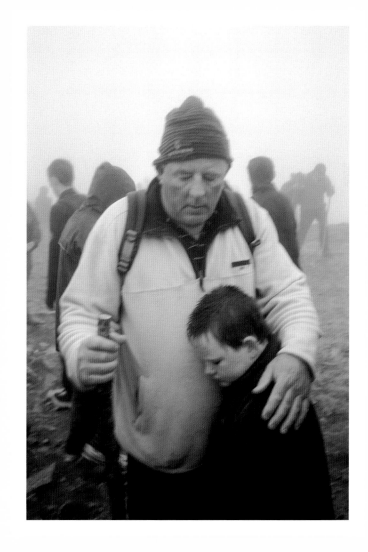

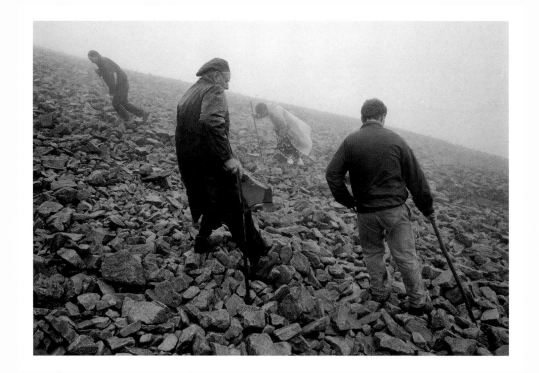

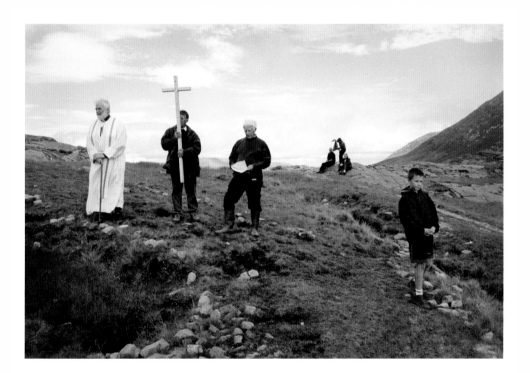

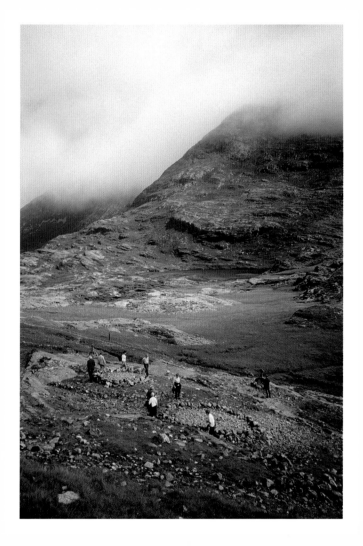

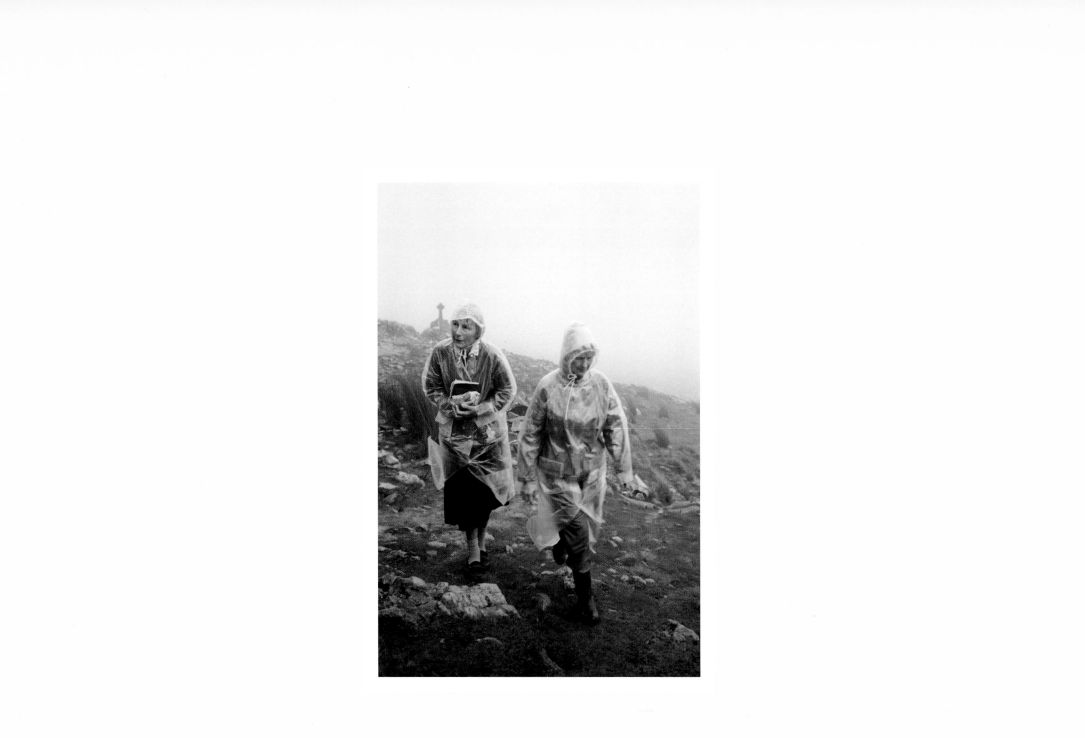

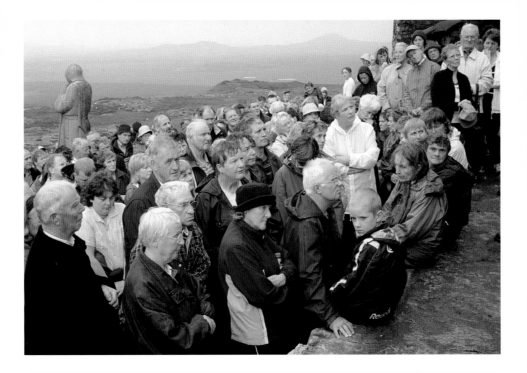

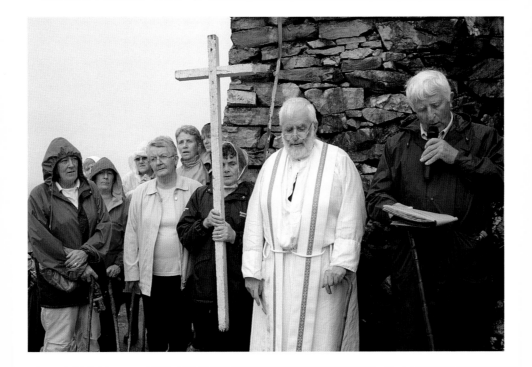

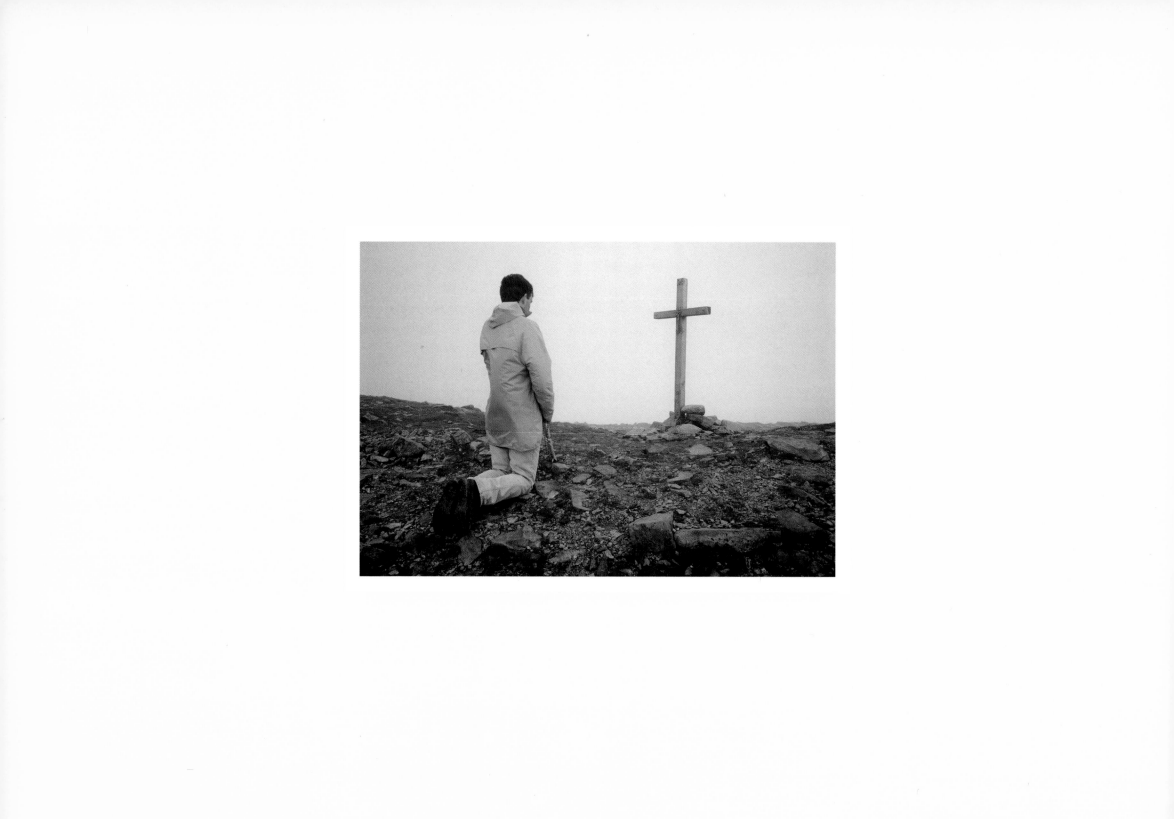

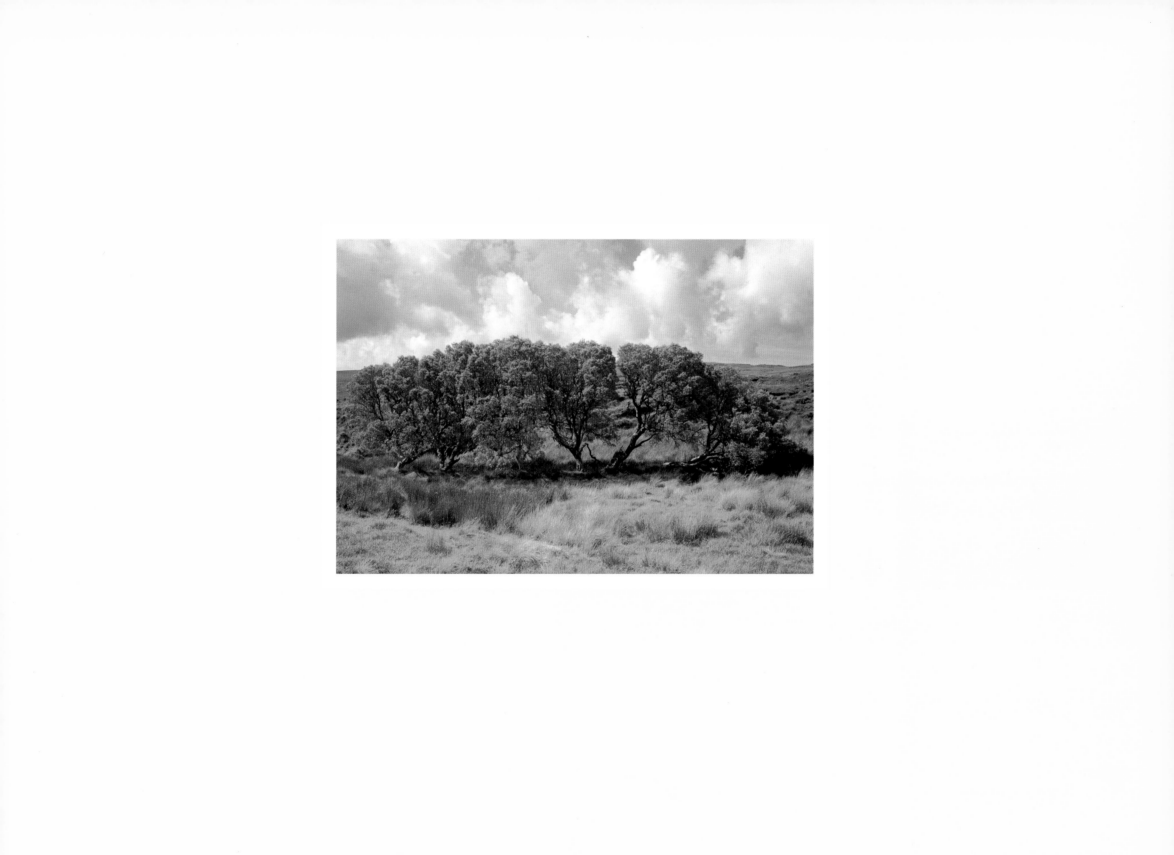

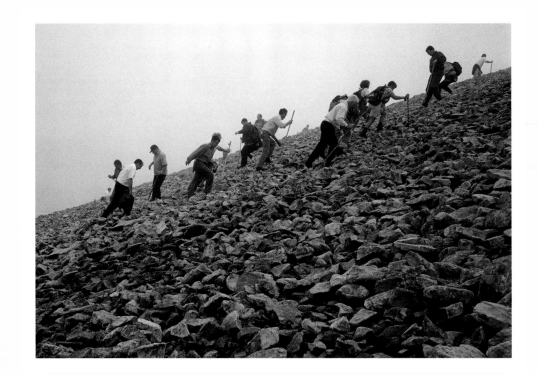

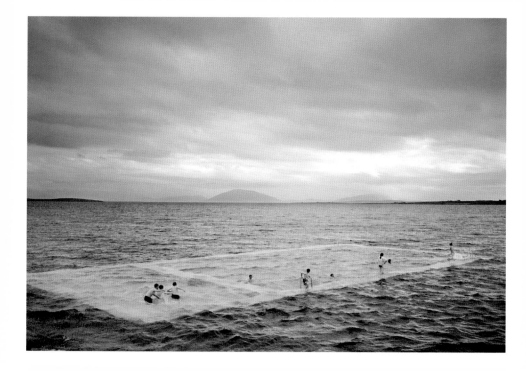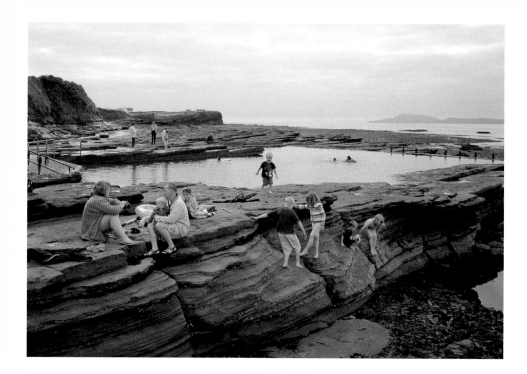
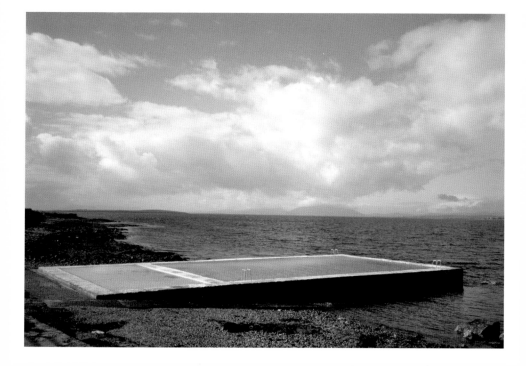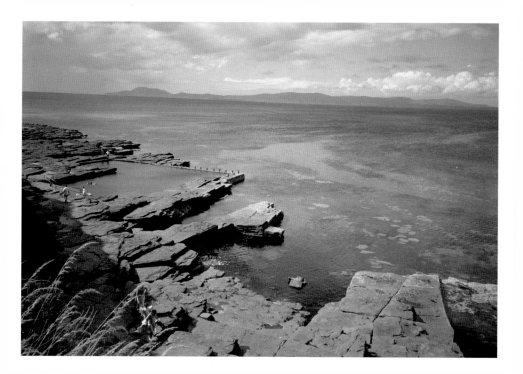

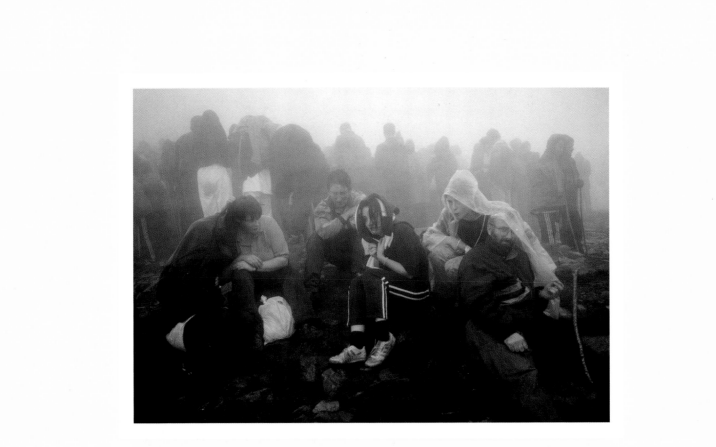

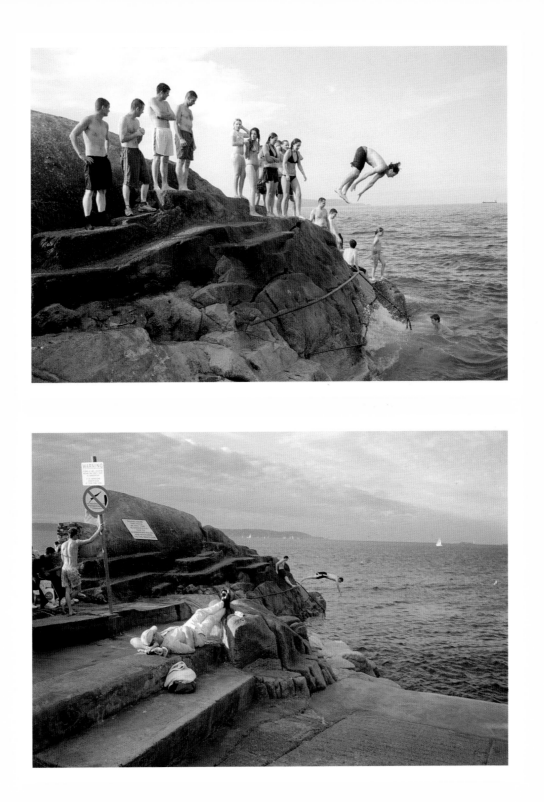

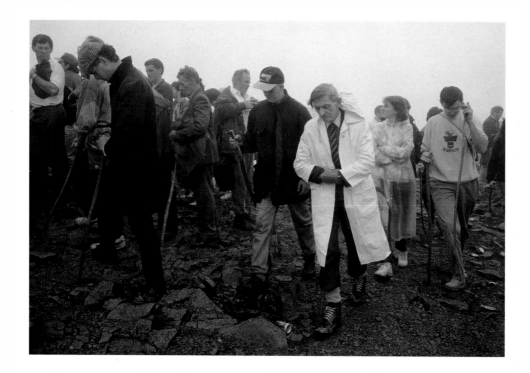

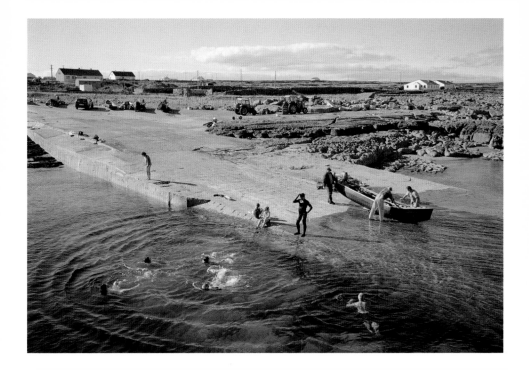

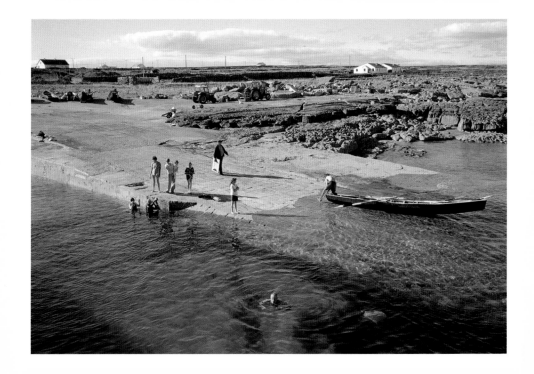

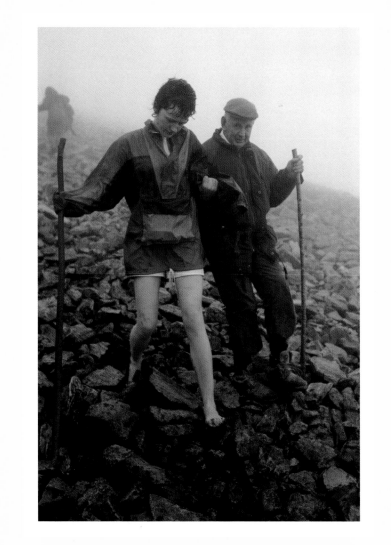

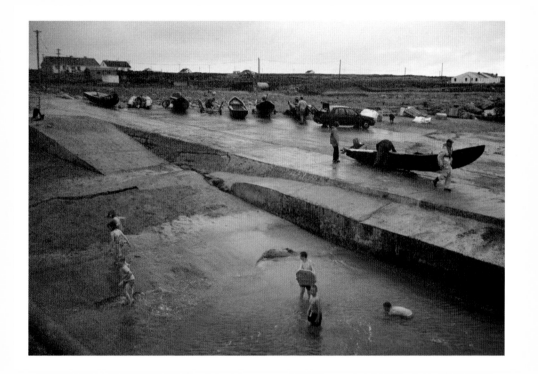

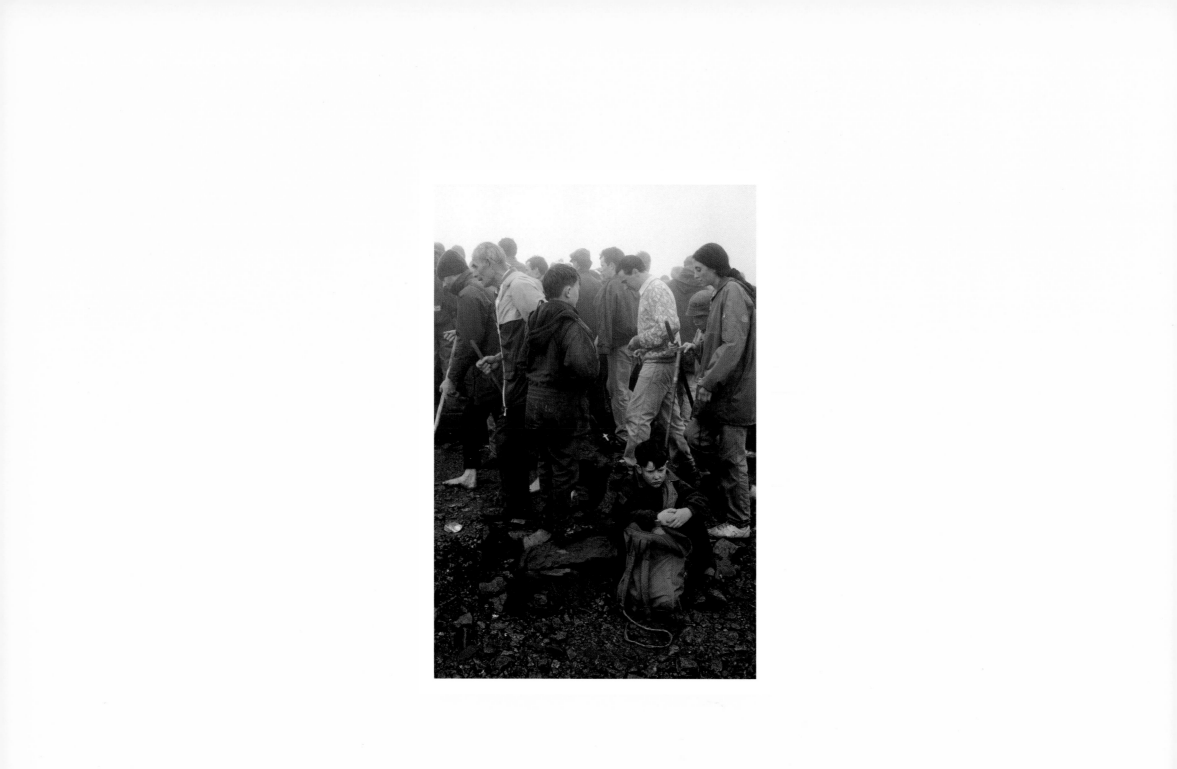

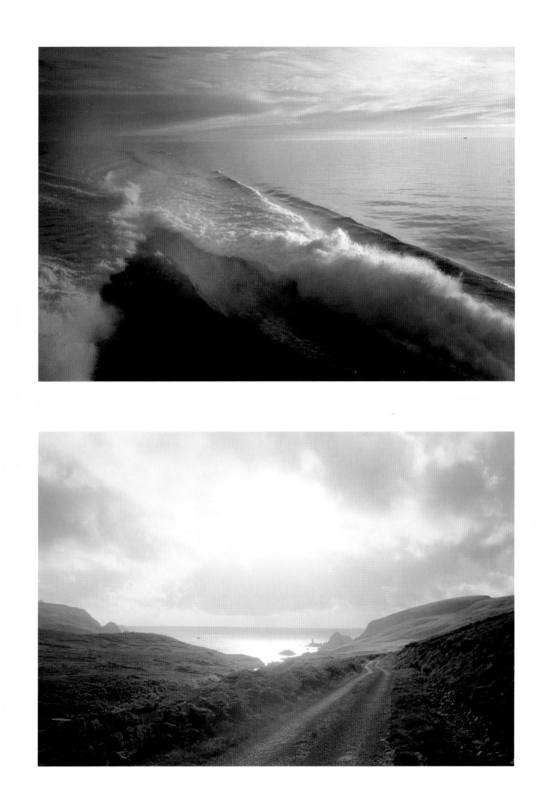

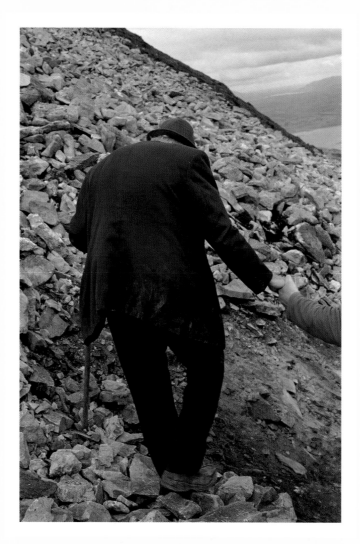

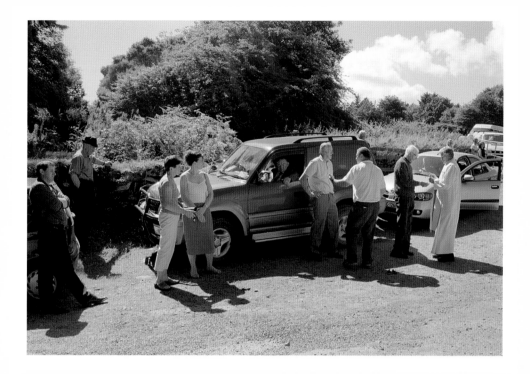

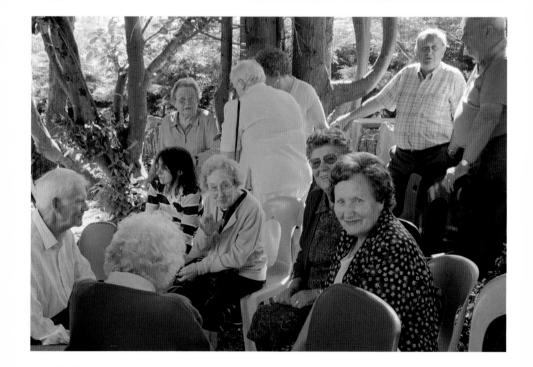

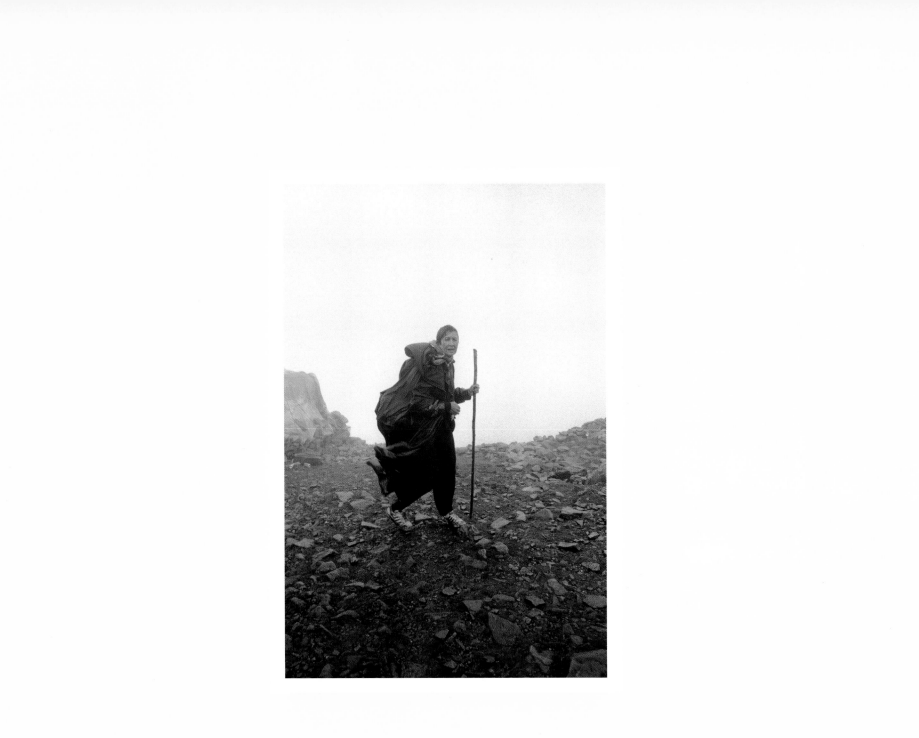

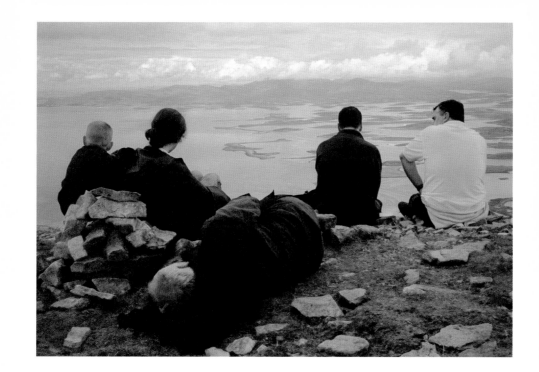

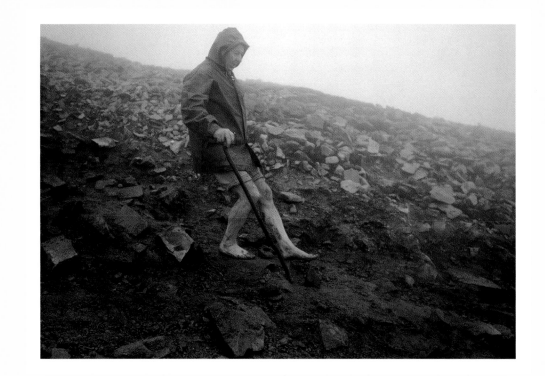

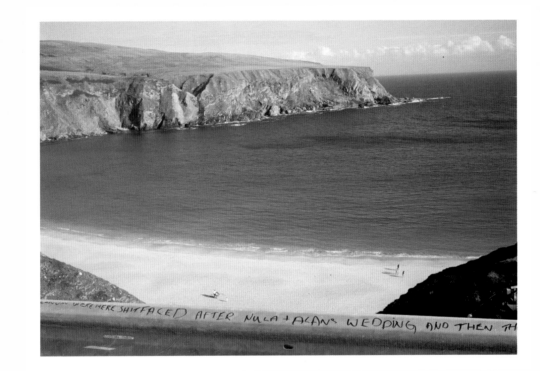

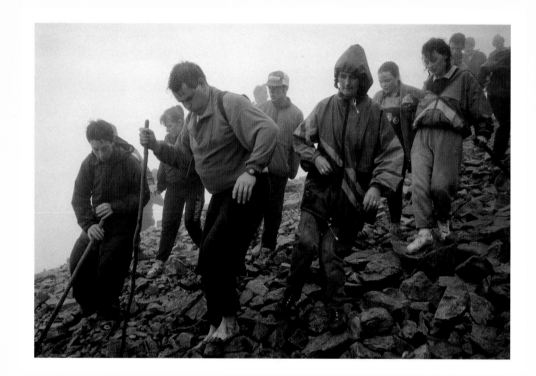

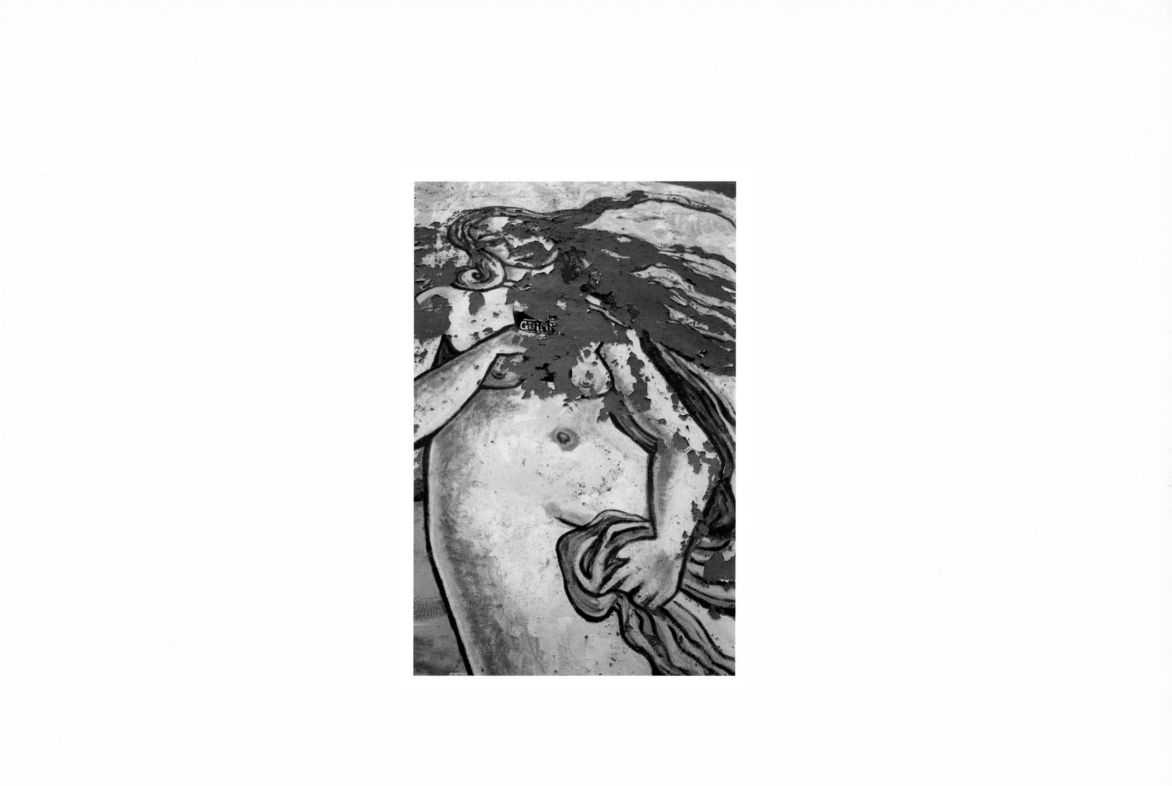

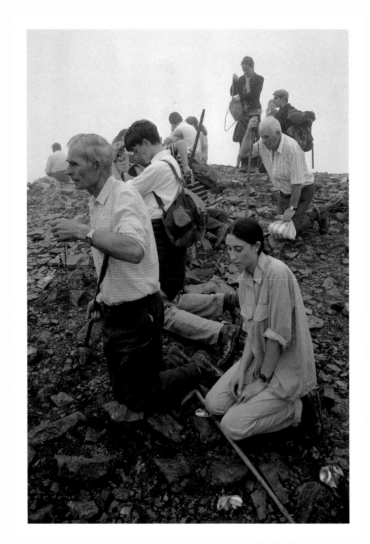

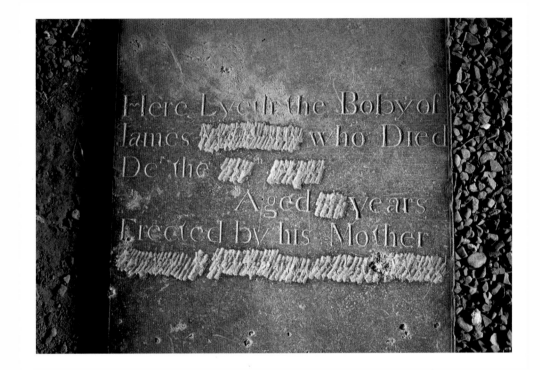

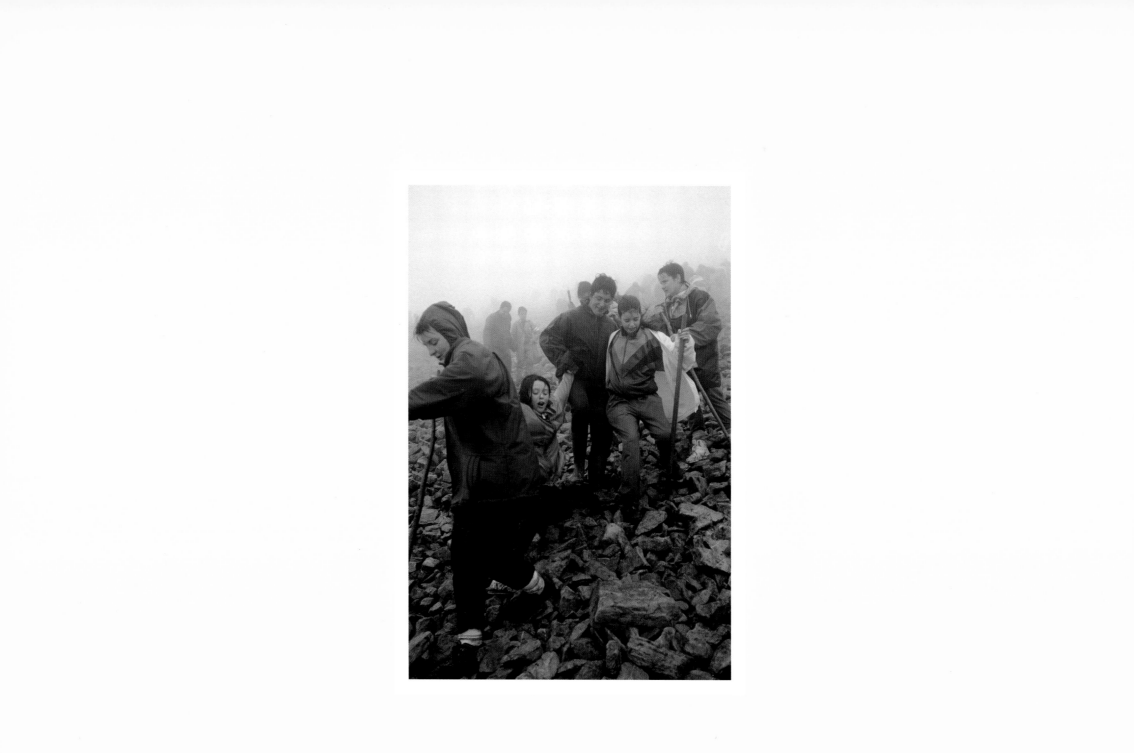

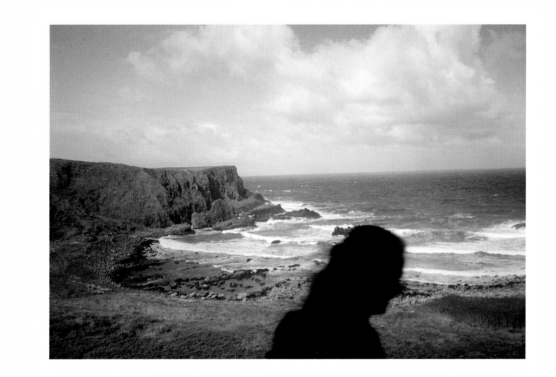

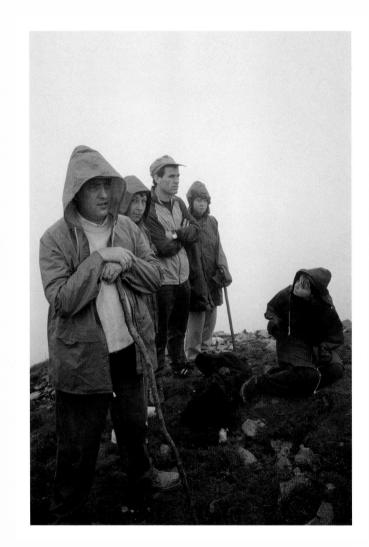

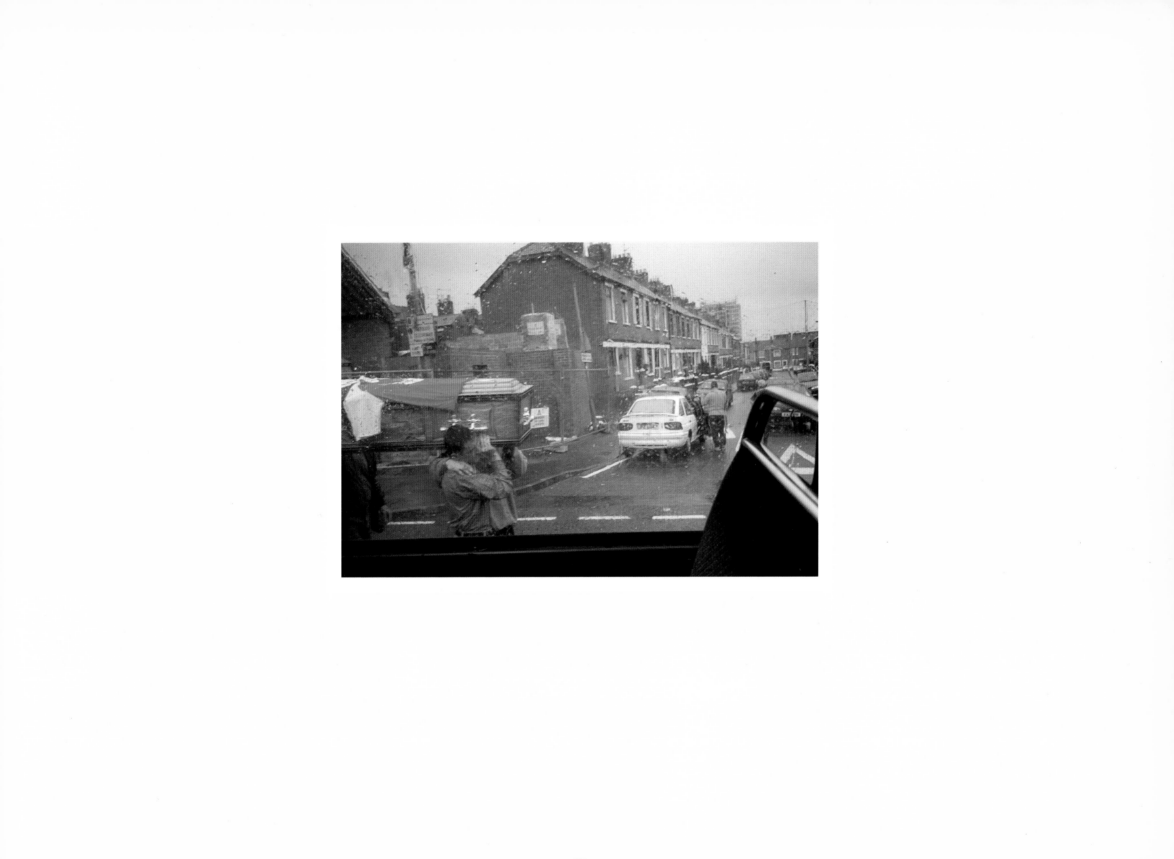

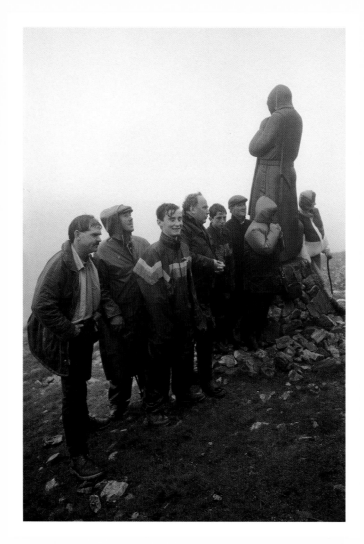

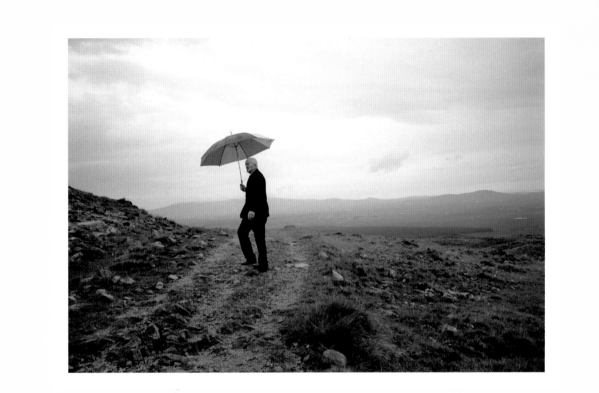

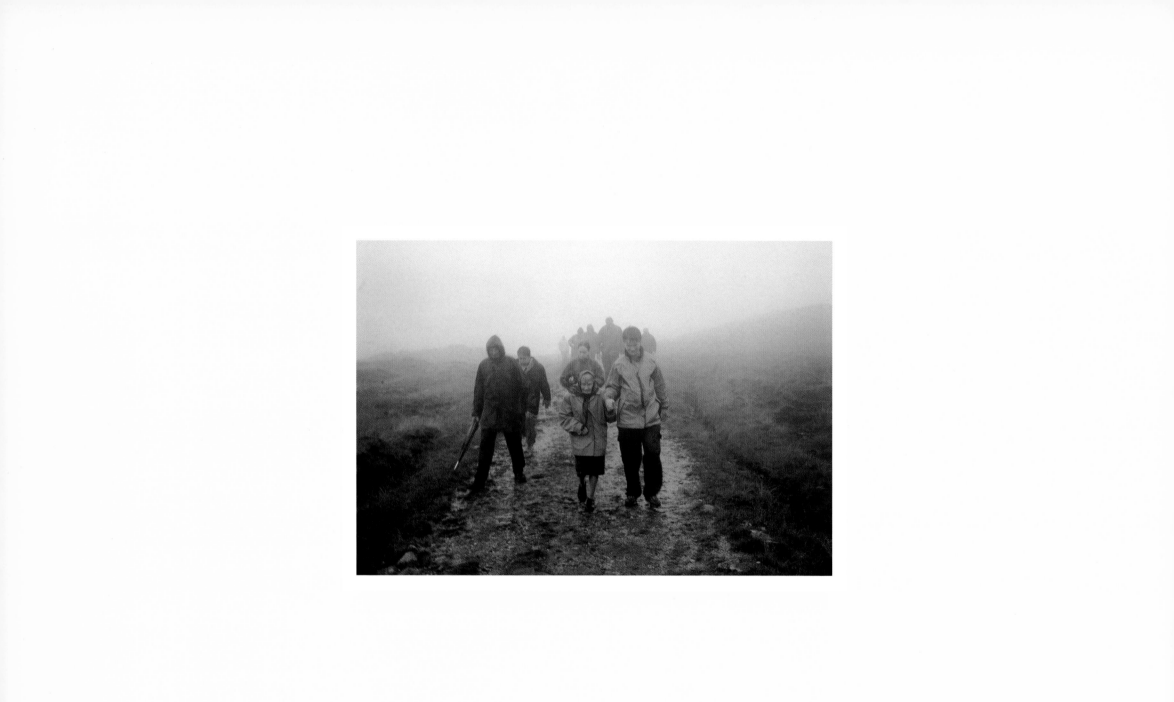

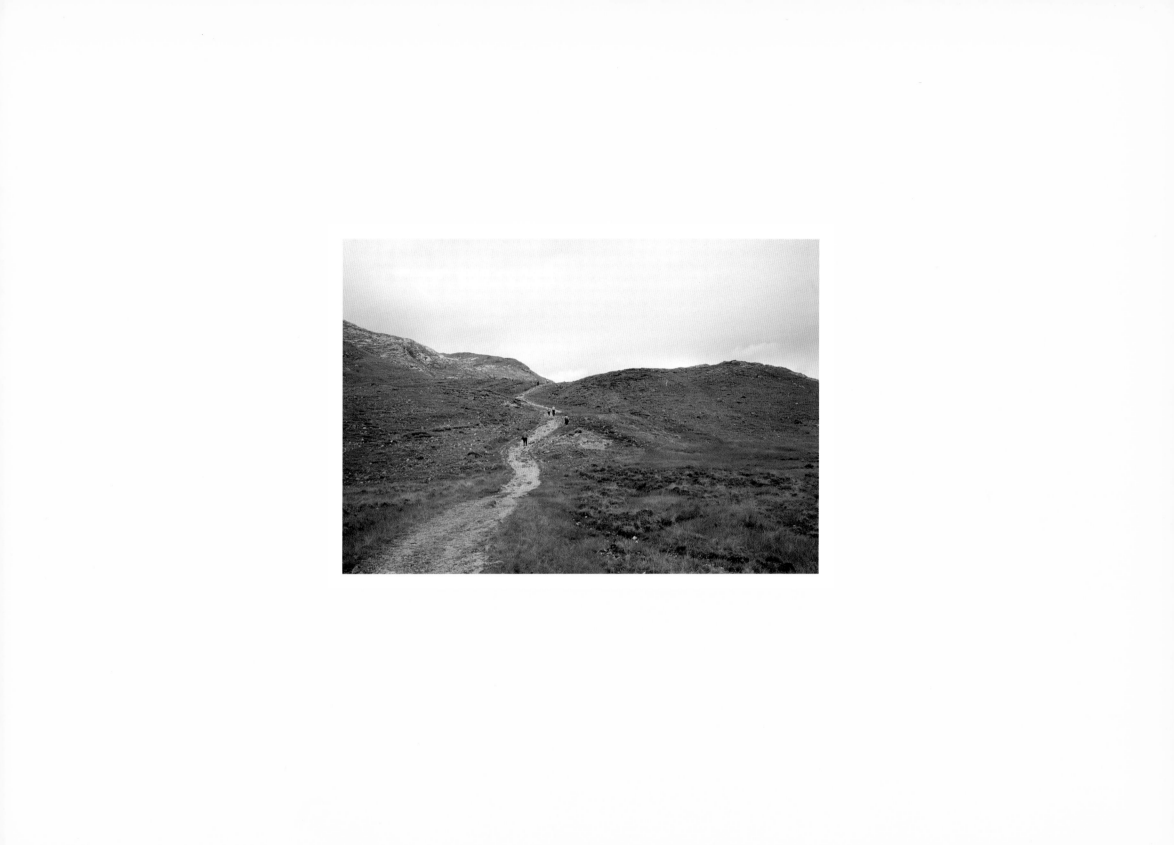

LOCATIONS AND DATES

Numbers refer to page numbers. Multiple photographs on a single page are identified clockwise from top left.

2 The slipway, Inis Meáin, the middle island of the Aran Islands, Co. Galway

8 Máméan, Co. Galway

9 The view from the car, near Enniscrone, Co. Sligo

10 Máméan, Co. Galway

11 The road on Dursey Island, Co. Cork

12 Máméan, Co. Galway

13 The Atlantic Ocean from Tory Island, Co. Donegal

14 Máméan, Co. Galway

15a Road, Co. Kerry

15b Road, Inis Meáin, Aran Islands, Co. Galway

16 Máméan, Co. Galway

17a, b Inis Meáin, Aran Islands, Co. Galway

18 Croagh Patrick, Co. Mayo

19 Croagh Patrick, Co. Mayo

20 Croagh Patrick, Co. Mayo

21 The Atlantic Ocean from the Aran Islands, Co. Galway

22 Croagh Patrick, Co. Mayo

23a Playing soccer on the road, Glencolumbkille, Co. Donegal

23b From the car, on the road near Carraroe, Co. Galway

24 Croagh Patrick, Co. Mayo

25a West Town, Tory Island, Co. Donegal

25b From the car, on the road to Killarney, Co. Kerry

26 Croagh Patrick, Co. Mayo

27a Stone gate, Inis Meáin, Aran Islands, Co. Galway

27b Stone gate, Inis Meáin, Aran Islands, Co. Galway

27c Stone gate, Inis Oírr, the smallest of the Aran Islands, Co. Galway

27d Stone gate, Inis Meáin, Aran Islands, Co. Galway

28 Croagh Patrick, Co. Mayo

29a Oil drum gate, Inis Oírr, Aran Islands, Co. Galway

29b Net gate, Inis Oírr, Aran Islands, Co. Galway

29c Steel rod gate, Inis Meáin, Aran Islands, Co. Galway

29d Whalebone gate, Inis Oírr, Aran Islands, Co. Galway

30 Croagh Patrick, Co. Mayo

31 Inishbofin, Co. Galway

32 Máméan, Co. Galway

33 Ballyvourney roadside, Co. Cork

34 Croagh Patrick, Co. Mayo

35 Inis Meáin, Aran Islands, Co. Galway

36 Croagh Patrick, Co. Mayo

37a–d Cottage and field, Inis Meáin, Aran Islands, Co. Galway, 1994–2005

38 Croagh Patrick, Co. Mayo

39 The graveyard at Cill Cheannanach, Inis Meáin, Aran Islands, Co. Galway

40 Croagh Patrick, Co. Mayo

41a Inis Meáin, Aran Islands, Co. Galway

41b Tory Island, Co. Donegal

41c Inis Meáin, Aran Islands, Co. Galway

41d Inis Meáin, Aran Islands, Co. Galway

42 Croagh Patrick, Co. Mayo

43a, b The road to Synge's Chair, Inis Meáin, Aran Islands, Co. Galway

44 Croagh Patrick, Co. Mayo

45a Hay field, Co. Donegal

45b Cattle, Co. Kerry

46 Croagh Patrick, Co. Mayo

47a Shrine, East Town, Tory Island, Co. Donegal

MY MOTHER

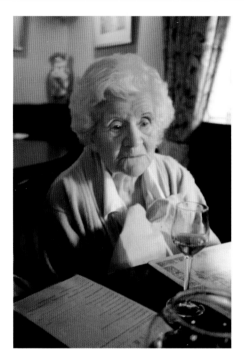

'Molly' Killip in 1994

I was thirteen when one afternoon at school I was overcome by an intense pain in my groin. Without speaking I got up from my desk, left the classroom and walked home. When I arrived I thought I could hear the sounds of someone playing the piano.

Cautiously I opened the door to the lounge then, slumped against the wall, I said to my mother, 'I didn't know that you smoked or that you played the piano.' Turning around my mother looked at me and said, 'There are a lot of things in this world that you don't know. Now, why are you home?'

ACKNOWLEDGMENTS

I would like to thank all of my friends in Ireland, especially: Joël D'Anjou, Liam Blake, Ken Grant, Anthony Haughey, Trish Lambe, Mairten Mullen, Pádraig Murphy, Brian, Johnny, Sue, Pete and Paul Redmond, Pete Smyth, Tom Wood and family, and Peter Zoeller.

Thanks to Fr. Micheál Mac Gréil S.J., the sean-nós singer Joe-John Mac An Iomaire, and all the pilgrims and clergy of Máméan and Croagh Patrick, as well as all of the other people that I photographed for their tolerance of my camera.

Also to Kent Rodzwicz for all his work on the scans, and my former assistants at Harvard, Myles Paige and Andrew Suggs, who also helped with the early stages of this book.

Finally, I'm most indebted and forever grateful to Christine Redmond for her friendship, her unfailing generosity, and for inviting me to Ireland in the first place.

All Rights Reserved. No part of this publication may be
reproduced or transmitted in any form or by any means,
electronic or mechanical, including photocopy, recording
or any other information storage and retrieval system,
without prior permission in writing from the publisher.

First published in 2009 in hardcover in the United States
of America by Thames & Hudson Inc., 500 Fifth Avenue,
New York, New York 10110

thamesandhudsonusa.com

Library of Congress Catalog Card Number 2008908219

ISBN 978-0-500-54365-8

Printed and bound in China by Sing Cheong Printing Co. Ltd.